IMAGES
of America

HANNIBAL
MISSOURI
BLUFF CITY MEMORIES

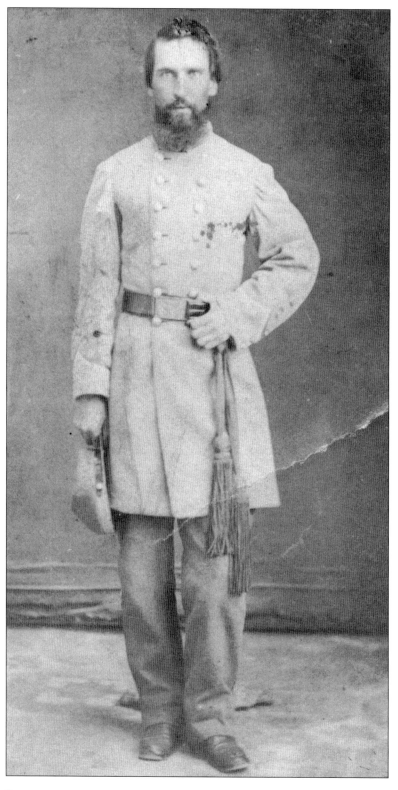

This is Capt. George W. Bates, son of Hannibal founding father Moses D. Bates. During the Civil War, Bates served in the Missouri State Guard, which fought for the South. Bates fought at the battle of Wilson's Creek. This photo dates from about 1861. (From the author's collection.)

IMAGES
of America

HANNIBAL
MISSOURI
BLUFF CITY MEMORIES

Steve Chou

ARCADIA

Published by Arcadia Publishing,
an imprint of Tempus Publishing, Inc.
3047 N. Lincoln Ave., Suite 410
Chicago, IL 60657

Printed in Great Britain.

Library of Congress Catalog Card Number: 2002110024

For all general information contact Arcadia Publishing at:
Telephone 843-853-2070
Fax 843-853-0044
E-Mail sales@arcadiapublishing.com

For customer service and orders:
Toll-Free 1-888-313-2665

Visit us on the internet at http://www.arcadiapublishing.com

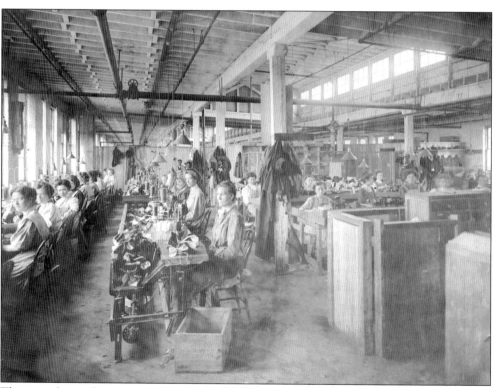

This is a photo of women working at the Bluff City Shoe Factory, which was located at the intersection of Maple and Collier. The factory, opened in 1904, employed several thousand workers, and eventually merged with International Shoe Company. It closed in the 1960s. The old factory, used for storage in later years, was destroyed by fire in February 2002. (From the author's collection.)

CONTENTS

ACKNOWLEDGMENTS

I am deeply indebted to Hurley and Roberta Hagood for their inspiration, encouragement, and advice over the years in my study of Hannibal's history. They always had time to help me find the answers to my multitude of questions. In the preparation of this book, I am most grateful for the use of material and information from the railroad collection of Archie Hayden. I am also very grateful for the wonderful photos contributed by Kathy Threlkeld, who was a tireless researcher of names and details I could not readily lay my hands on. And I want to acknowledge, above all, my most patient and beloved wife, Linda, for her encouragement and support of my work on this book. Without her, this book would not exist.

INTRODUCTION

Nestled between the "bluffs" of Lovers Leap to the south and Cardiff Hill to the north, Hannibal was nicknamed the Bluff City. *Bluff City Memories* is a photographic journey into the history of this city. It is by no means a definitive history, nor are there representative images of every important event and place. It is, rather, an eclectic gathering of rare old photographs (some never before published), ranging from the 1860s to modern times. Taken as a whole, they give a feel for the growth and changes that Hannibal has undergone over the years.

I have thus chosen to arrange this book chronologically rather than thematically. The book is broken down into four broad chapters. The first chapter deals with the first 70 years, from Hannibal's founding in 1819 through 1889. The second chapter covers Hannibal's golden age of growth and prosperity, from 1890 through 1929. Chapter Three looks at Hannibal during times of economic depression and World War II, 1930 through 1945. The fourth chapter deals with life and times in Hannibal from 1946 through the early 1960s.

Chapter One spans a 70-year period, yet it is only from the last part of that period that actual photographs exist. What material there is documents a town that is barely recognizable to us today. Dirt streets, plank sidewalks, and gas street lighting were all typical sights. Although some of the photos lack the quality of later images, they give a fascinating glimpse into the time when Hannibal, recovering from the misfortunes of the Civil War, was beginning to grow.

The period covered by Chapter Two was a very exciting one for Hannibal. With a booming lumber industry (Hannibal was the fourth largest lumber center in the country at one time) and the railroads, the little river town was quickly growing into a real city. New public buildings, churches, and homes were being built. As the lumber mills died out, the shoe manufacturing industry rose to take its place. The cement plant just south of town contributed to the area's prosperity. Local photographer Anna Schnitzlein was taking pictures at this time, and some of her candid photos of everyday life along Market Street are included here.

Chapter Three spans a time period of great trial for our nation, and the city of Hannibal as well. After the stock market crash in 1929, businesses failed and people lost their jobs. The coming of World War II saw many going off to join in the fight for democracy, while those at home served in the factories and counted ration stamps. Yet during that time, positive things were happening in Hannibal. A new highway bridge across the Mississippi opened, and the modern tourist industry was born around Hannibal's favorite son, Samuel Clemens, or Mark Twain.

The Fourth Chapter is filled with photos that mark the time before so many of Hannibal's downtown businesses closed their doors. Pictures of clothing stores, restaurants, grocery markets, and dime stores should bring back fond memories for many readers. Included in this chapter are photos that give a last look at Hannibal's beloved old Union Depot before it disappeared into the dustbin of the past.

I have gotten a great deal of enjoyment in putting this book together. The collection and study of relics of Hannibal's wonderful past has been a hobby of mine for many years now. As I reviewed old photos and postcards from my collection, as well as material from other individuals, there was simply not enough room to include everything that I had wanted to within one book. But what I have selected is intended to take you on a visual journey from Hannibal's distant past to modern times. If you have even half as much fun poring over these collected images as I have had gathering them into this volume, I will consider my efforts successful.

Steve Chou
June 2002

One

BEGINNINGS AND GROWTH

1819–1889

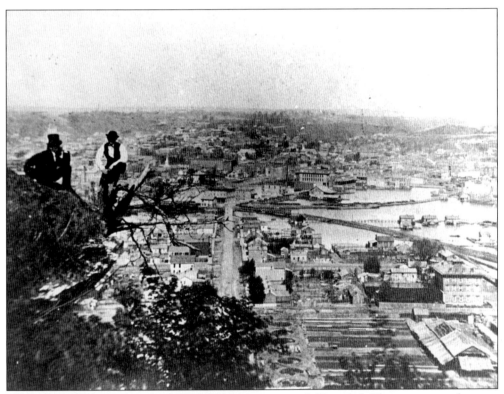

This view from Lovers Leap (c. 1865–1870) looks over south Hannibal. There appears to be some flooding at the time of the photo. Union Depot, built in 1882, does not appear in this image. The large building at lower right is the Hannibal-St. Jo office building. Main Street is in the center of the photo. Also visible are the old Kettering Hotel, Brittingham Hall, and the steeple of the old First Baptist Church. Note the fellow in the top hat at left. (Courtesy of Hannibal Public Library.)

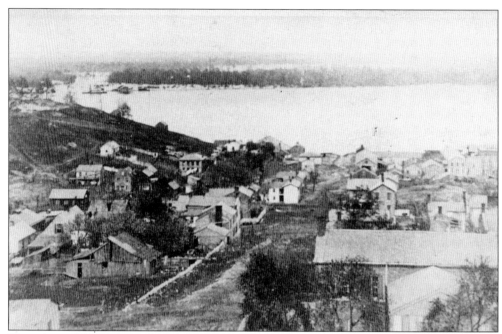

This photo shows a Hannibal that old Mark Twain might readily recognize. Looking down North Street towards the river, this photograph was probably taken in the late 1860s or early 1870s. Notice how barren of trees Cardiff Hill is in this picture. Visible also are the top of the old Huck Finn home and the old jailhouse beyond. (From the author's collection.)

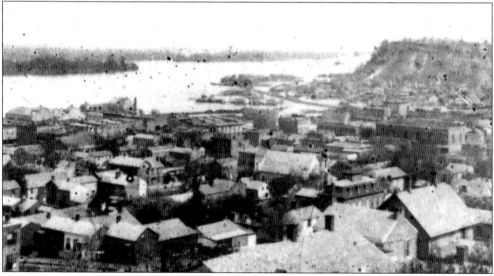

A rapidly growing city can be seen in this *c.* 1875 bird's-eye view looking toward Lovers Leap and the river. The mansard roof of the Frederick Dubach House at Fifth and Bird can be seen toward the lower right of the photo, and the large building at middle right is Brittingham Hall (300 block of Broadway). This photo was taken during one of Hannibal's many floods, as high water can be seen at the base of Lovers Leap. The line that runs below the Leap out towards the river was a spur of the Hannibal-St. Jo Railroad that ferried passengers to and from a riverboat landing. (From the author's collection.)

R.E. Lackner operated a store in this building at the southwest corner of Broadway and Main when this photo was taken around 1865. He sold watches and jewelry as well as other merchandise. Bob Heiser of Crescent Jewelry is a great-great-great-grandson of Mr. Lackner. Crescent Jewelry celebrated its 160th anniversary in 2002. The large glass window on the second floor was for a photography studio. Note the wooden Indian in front. (Courtesy of Bob Heiser.)

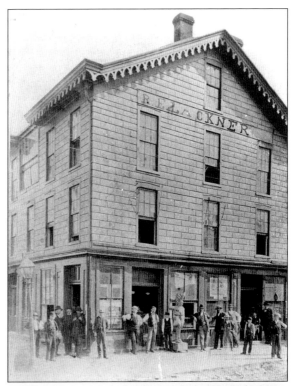

The faces staring back at us in this *c.* 1870 photo are those of Hannibal's working class. This is a shot of workers at the iron foundry in the railroad yards. Their lot was a very hard one. Note how they are posed with their tools. (From the author's collection.)

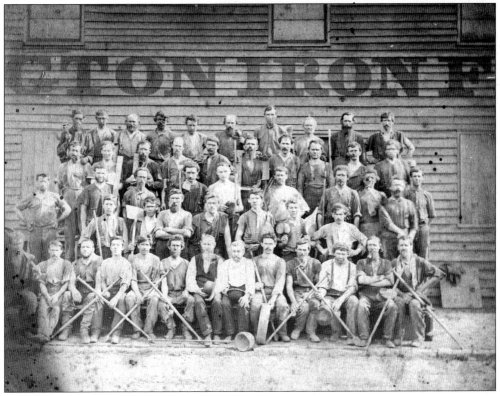

This photo looks toward the 100 block of North Fifth Street from Central Park. Taken from a stereoscope view card by an unknown photographer, it dates from the spring of 1872. The original Fifth Street Baptist Church, built in 1869, is visible at left. It would be replaced by the current church building in 1893. Next to it is the old McCooey house, which would be razed for the Sultzman Clinic around 1937. Beyond them is the steeple of the old Presbyterian Church, which would be replaced by the current one in 1895. The Park Opera House would not be built until 10 years after this photo was taken. Notice the wooden fence around the park, which was later replaced by an iron one. (From the author's collection.)

Here is another early stereopticon photo showing the recently built C.O. Godfrey Mansion on Bird Street near Maple in 1872. Godfrey was one of Hannibal's wealthiest citizens at the time, and this home was then noted as one of the finest in this part of the state. The home was replaced in the early 1900s by the Pettibone Mansion (Cliffside Manor). Notice the gaslight and the nearby ladder that was used to light it each night. (From the author's collection.)

This 1872 stereopticon image shows a view east across the river toward Illinois from the Missouri approach on the new Wabash Railroad Bridge. Notice the iron plate atop the first span which reads "1871 Hannibal Bridge." The Hannibal Bridge was only the fourth bridge to span the Mississippi north of St. Louis and was key to the development of the railroads in Hannibal. (From the author's collection.)

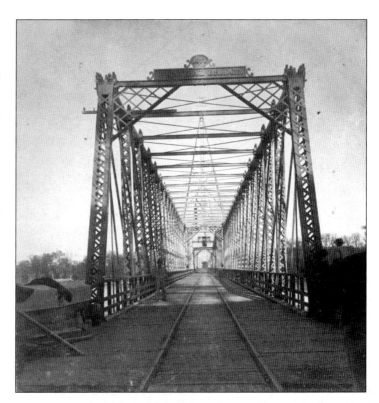

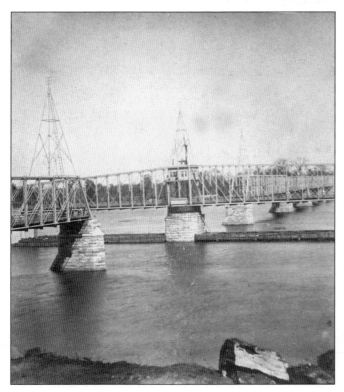

This is yet another of the series of 1872 stereopticon views done by the same unknown photographer. Here the swing span of the new Hannibal Bridge is shown open, allowing river traffic to pass. In 1913, due to several boat wrecks, this swing span was moved one span segment closer to the Missouri shore where the current was less swift. (From the author's collection.)

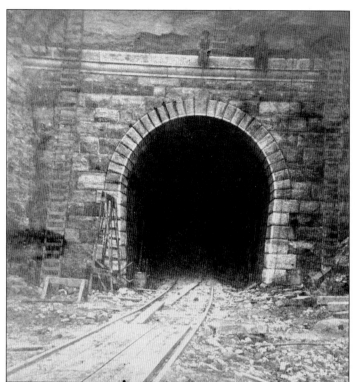

This is the eastern approach of the Wabash Tunnel during construction. Part of the 1872 series of stereopticon photos, the photo itself was probably taken in 1871. Visible are homemade ladders, construction tools, and two workers perched atop the stonework. (From the author's collection.)

This is a view on Market Street looking east, dating from around 1880. The street is dirt and the sidewalks are made of wood planking. Perhaps the dog belongs to the photographer. This photo is also taken from an early stereopticon view.

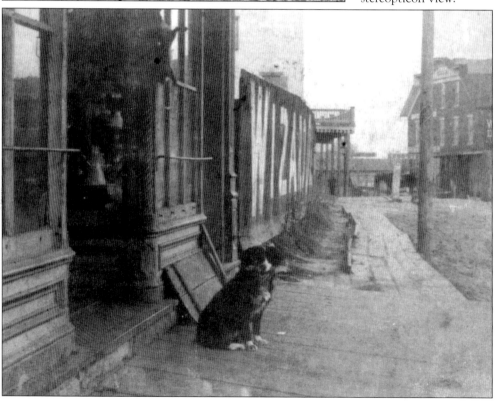

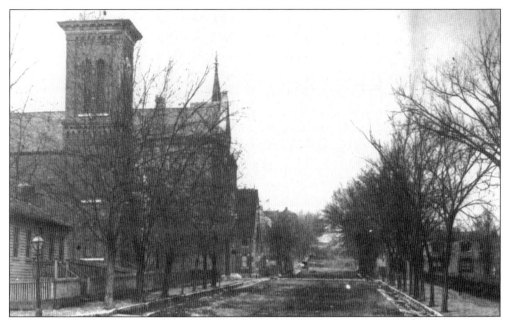

This old stereopticon view looks north on Fifth Street from Broadway. The old Fifth Street Baptist Church building stands at left, with the Park Opera House beyond. The top of the steeple of Park Methodist Church is visible above the opera house. Notice the crossing stones at the intersections (very handy with muddy streets) and the limestone gutters. This view dates from around 1883.

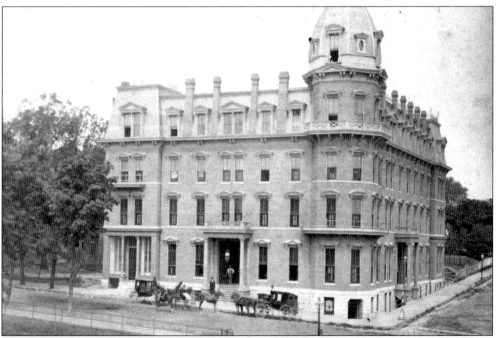

The Park Hotel, which stood at the northwest corner of Fourth and Center, was Hannibal's premier hotel in the last quarter of the 19th century. It was destroyed by fire in April of 1899. This photo was taken by E.A. Elsam shortly after the hotel was completed in 1879. (From the author's collection.)

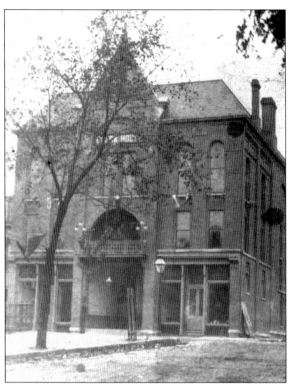

The Park Opera House stood at the corner of Fifth and Center. Purchased by the Hannibal Masonic Lodge in 1915, it was used as the Masonic Temple for nearly 75 years. It was razed for a parking lot in 1992. In its day, such notables as Lillian Russell, Buffalo Bill, and Harry Houdini performed here. This stereopticon photo by Calvin Jackson shows the opera house nearing completion in 1882.

The exact location of this building is not certain; quite possibly it was near the Wedge intersection of Broadway and Market. At one time there was a deep ravine at the end of Broadway past Maple that was filled in to extend the roadway beyond that point. This photo is significant in that it demonstrates how many of the streets today exist in their present form due to much filling and grading. It was taken from an old stereopticon photo from around 1880.

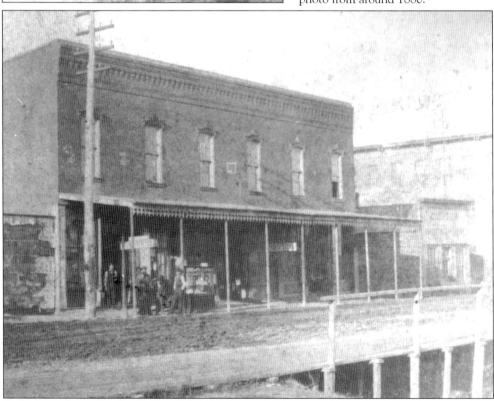

Hannibal has had its share of train wrecks over the years. This stereopticon photo by local artist Calvin Jackson shows an early wreck behind Union Depot about 1883. A destroyed Wabash boxcar lies just above the northern bank of Bear Creek, as a crowd of bystanders looks on. (From the author's collection.)

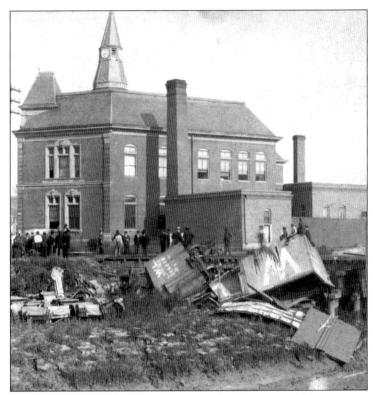

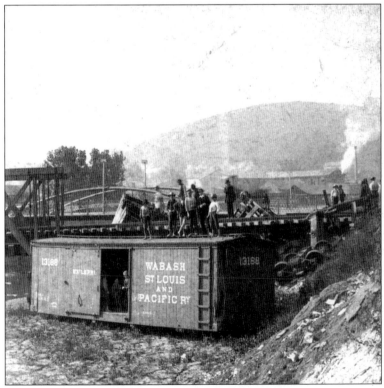

Here is another view of this 1883 train wreck, this one looking south towards Lovers Leap. The ever-present curious onlookers stand atop and inside a derailed boxcar. This stereopticon photo was also done by Calvin Jackson. (From the author's collection.)

This photo shows the 300 block of North Main as it looked *c.* 1885. At left is the old Planters Hotel. A long-time Hannibal landmark (Abe Lincoln was a guest here in 1860), it was razed for a parking lot in 1954. At right is the Pilaster House with a porch instead of the balcony we see today. (From the author's collection.)

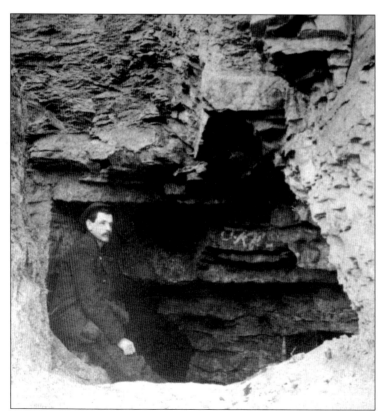

Known simply as "Hannibal Cave" when this photo was taken around 1880, Mark Twain Cave hardly resembles the major tourist attraction it is today. Pictured here is the original cave entrance. The present entrance was opened up in the 1890s. (From the author's collection.)

Two
HANNIBAL'S HEYDAY
1890–1929

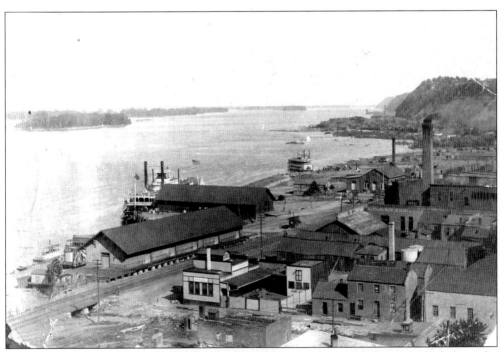

Here is a view of Hannibal's riverfront in the 1890s. Note the riverboats docked along the shore. The large smokestack at right belongs to the A.J. Stillwell Meat and Ice Company; the smaller one to the left of it marks the city's Electric Light Plant. The wharf house is on the river at left. The steamer "Flying Eagle" is visible along the riverfront in the distance. (From the collection of Hurley and Roberta Hagood.)

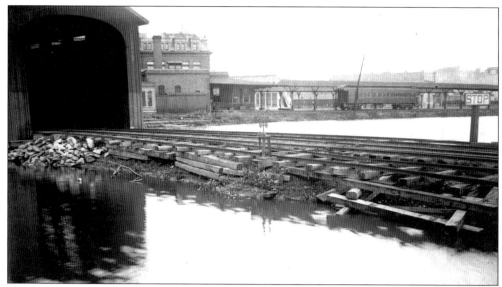

This photo shows the covered railroad bridge and the back of Union Depot during the flood of 1892. Photo was taken by S.G. Kent on July 9, 1892. Notice how the railroad is using old ties to shore up the trackbed in the foreground. The old covered bridge was replaced with a more conventional style a few years after this photo was taken. (Courtesy of Archie Hayden.)

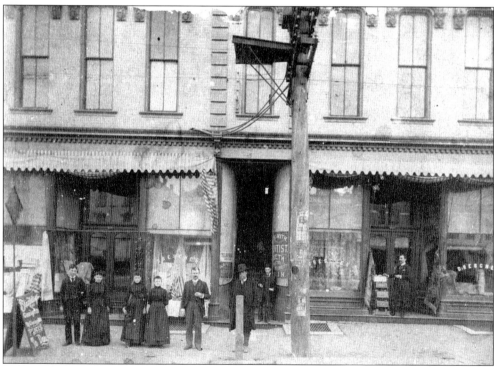

This 1894 photo shows what later became known as the Catlett Building on the south side of the 200 block of Broadway. Drescher's Dry Goods was located on the ground floor of this building. Upstairs was the Missouri and Kansas Telephone Company; note the cables going from the pole into the side of the building. This building burned in 1967. (From the author's collection.)

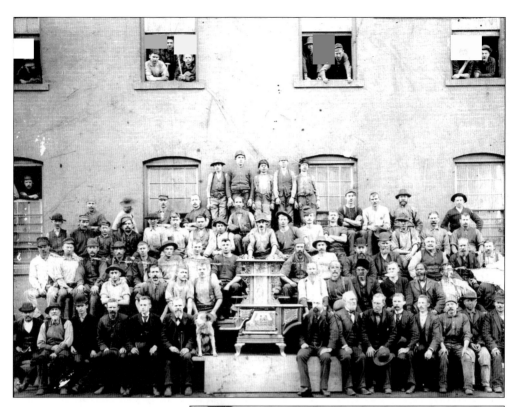

This is a group photo of Duffy-Trowbridge Stove Company workers from the 1890s. These workers have proudly displayed one of their new stoves in the middle of the photo. Duffy-Trowbridge was located at 300 South Eighth. (From the author's collection.)

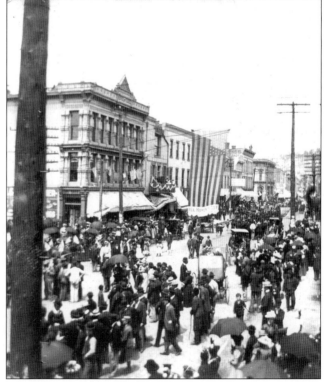

This photo shows the celebration held for the mustering in of the 109 men of Hannibal Company F of the Missouri Volunteer Infantry for service in the Spanish American War on May 16, 1898. It was taken at Broadway and Main, looking north on Main. (From the author's collection.)

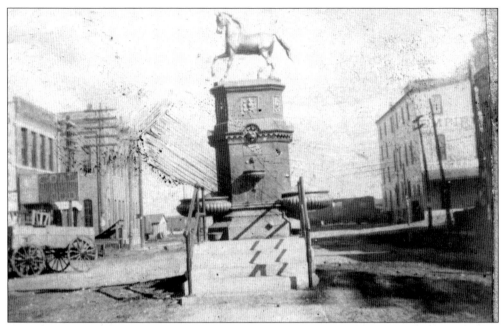

The McKnight Fountain was a famous landmark in downtown Hannibal. It was given to the city in 1898 by lumber magnate Sumner McKnight in memory of his wife. Topped by a near life-size statue of a horse, the fountain featured two watering troughs for horses on each side, and in the center, a community drinking fountain. If you look carefully near the base, you will see the tin cup that was used for the public. The fountain stood on East Broadway at Main Street. As horses gave way to the automobile, the fountain was moved to Central Park (1912) and sold for scrap in the 1920s. (From the author's collection.)

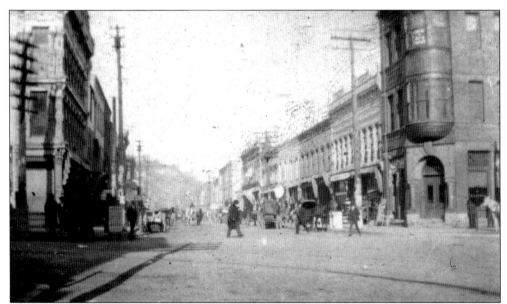

This 1899 photo looks north on Main Street from Broadway. The original facade of Hannibal National Bank (at that time, Bank of Hannibal) is plainly visible on the right. (From the author's collection.)

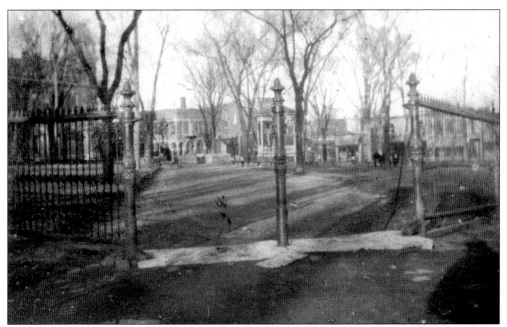

Looking into Central Park from the Fifth and Broadway entrance, note the iron fence, which enclosed the park from about 1880 to the early 1900s. Visible through the trees at the far left is the silhouette of the old Park Hotel. This photo dates from early 1899. (From the author's collection.)

South School sat on the site of the present Stowell School. Stowell replaced this school in 1924. The empty lot at right is where the Southside Baptist Church now sits (2002). This photo dates from 1899. (From the author's collection.)

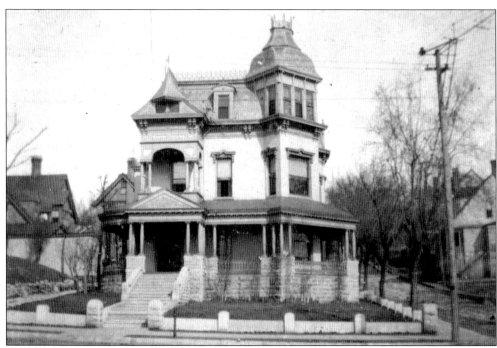

Known for years as Schwartz Funeral Home, this landmark at Broadway and Tenth was the residence of Hannibal attorney George Mahan when this photo was taken in 1899. This beautiful building was destroyed by fire July 4, 1983. A high-rise apartment building now occupies the site. (From the author's collection.)

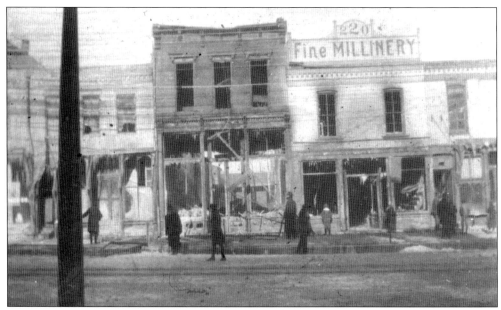

A disastrous fire in January of 1899 seriously damaged or destroyed half of the north side of 200 Broadway. Among the losses were Bowman and Williamson Dry Goods at 220 Broadway. In this photo you can see icicles hanging from the ruins. The buildings on the left side of the photo stood where the drive-through of MCM Savings now stands (2002). (From the author's collection.)

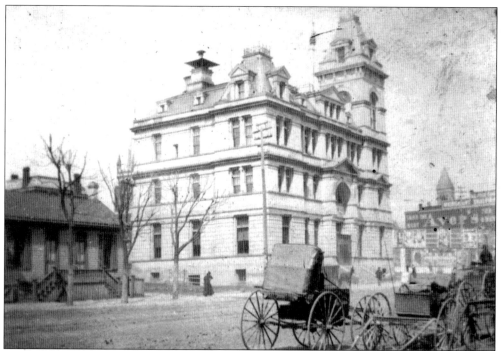

Here is Hannibal's Federal Building as it appeared in 1899. Completed in 1888, this building served as Hannibal's post office until 1966. The building has had several uses since that time, housing both the Naval Reserve Center and a restaurant, among other things. The buggies on the right side of photo are parked in front of the Broadway Livery Stable. (From the author's collection.)

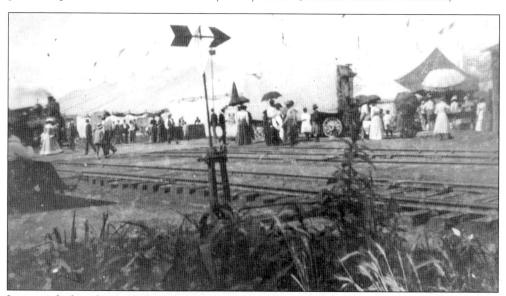

In a time before theme parks, television, and video games, the circus was an event long awaited by folks young and old. This 1899 photo shows one of Hannibal's early circuses. Generally the circus grounds were near a set of tracks where the circus train could readily unload and reload tents, wagons, animals, and gear. Many of Hannibal's circuses were held in the bottoms near Lindell Avenue. (From the author's collection.)

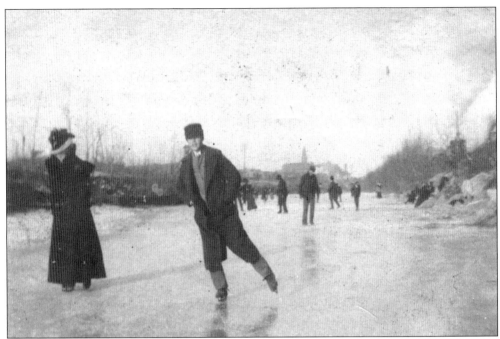

Ice skating was a popular winter recreation in the 1890s, when this photo of skaters on a frozen Bear Creek was taken. Union Depot is visible in the background. (From the author's collection.)

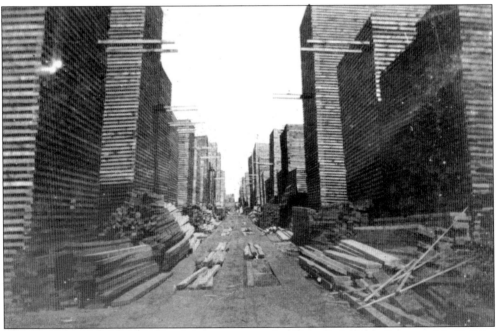

Many millions of board feet of lumber were processed in Hannibal during the second half of the 19th century. Timber from the virgin forests up north in Wisconsin and Minnesota were floated down the river to Hannibal and processed here. This 1899 photo shows a view in one of the lumber yards located where Clemens Field is today. Notice the tall stacks of lumber lined up in long rows. (From the author's collection.)

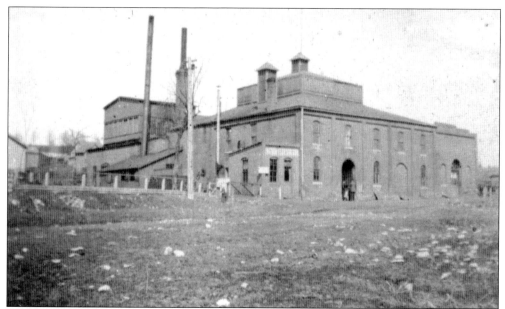

This is the City Brewery, which was located on Grand at Lincoln. Opened in 1854, the brewery was originally located on the river, north of downtown. When the old brewery was torn down in 1871 to make way for the Wabash Bridge, the brewery relocated to this spot. Natural springs in the area made this an ideal location. City Brewery closed by 1903. This shows the brewery as it looked while in business in the 1890s. (From the author's collection.)

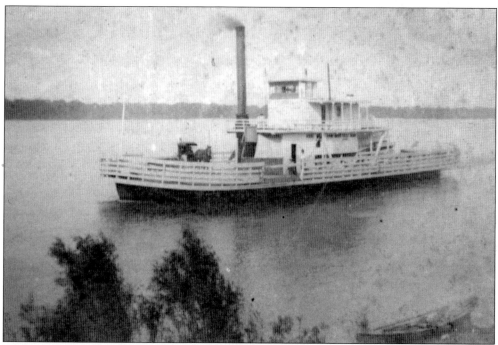

This view from the 1890s shows the Hannibal Ferryboat *J.T. Davis*. Hannibal's ferryboat service across the Mississippi started before 1840, and the *J.T. Davis* was the last of Hannibal's ferries. Service ended in the early 1900s. (From author's collection.)

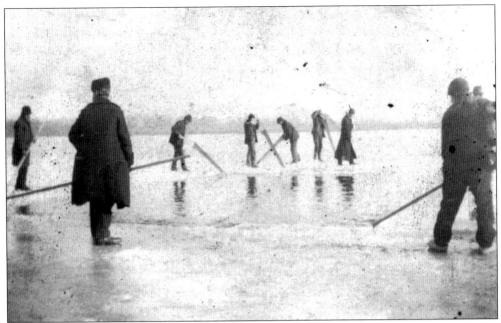

Long before electric refrigerators, people used real ice to keep food cold. Ice was harvested from rivers in the winter and stored in large sawdust-filled buildings where it would keep for many months. This 1899 photo shows workers from the Storrs Ice and Coal Company harvesting ice from the Mississippi River. They are using large ice saws to cut the ice into blocks. (From the author's collection.)

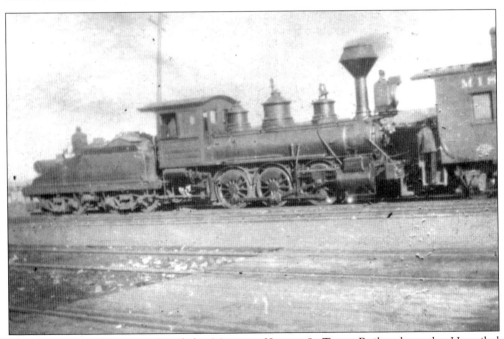

This is a view of Engine #91 of the Missouri, Kansas & Texas Railroad on the Hannibal riverfront. The locomotive was built in 1880 and scrapped in 1912. The photo dates from 1899. (From the author's collection.)

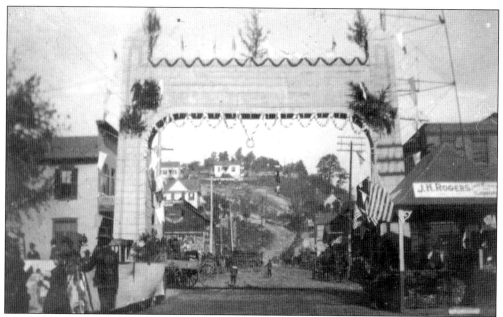

This photo shows the North Main Street entry arch erected during the 1899 Street Fair. This arch, made of wood, is decorated with garland, cedar boughs, and flags. Local merchants had booths up and down the street, and there were all sorts of carnival-type attractions and food. Notice how Main Street went all the way up Cardiff Hill at that time. The building at the left is the old Virginia Hotel, which stood at the intersection of Main and Hill, where the garden of the Mark Twain Home is now located. The tower at right is one of the city's early carbon arc light towers. (From the author's collection.)

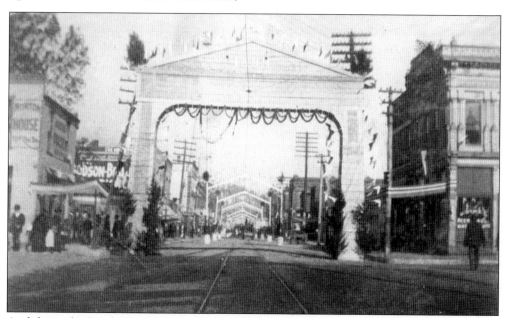

And this is the South Main Street entry arch of the 1899 Street Fair, at Main and Lyon Streets. The Mark Twain Hotel is not yet built; it would stand just beyond the building on the right hand side of this photo. (From the author's collection.)

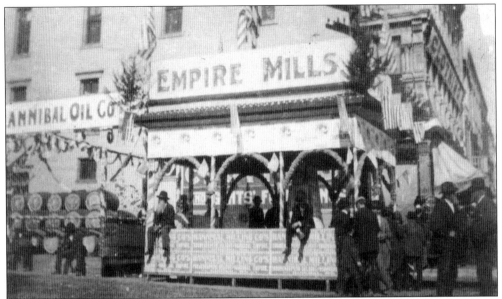

Here are a couple of the merchants' booths set up along the street during the 1899 Street Fair. Some of these booths were very elaborately decorated, and they were meant to call attention to the business and its wares. This photo was taken at the northwest corner of Broadway and Main and shows the booths for Empire Mills and Hannibal Oil Co. (From the author's collection.)

At one time, there were over 75 grocery stores in Hannibal; few homes were more than a block or two away from their corner grocery. This grocery store (c. 1898) did business at the corner of Union and Eighth Streets, on the south side. An old carbon arc light tower is at left. (From the author's collection.)

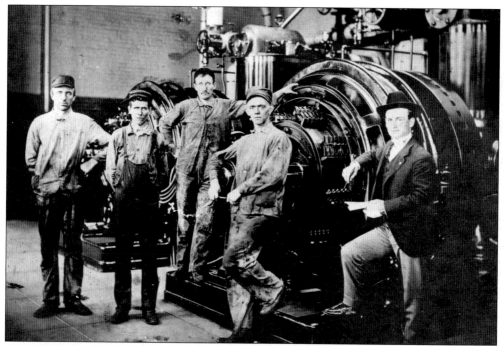

This photo (c. 1900) shows the crew of the power plant that drove the turntable of the roundhouse in the railroad yards. Note the huge dynamos in the background. Pictured at far left is Fred Bauchle; others are unidentified. (Courtesy of Archie Hayden.)

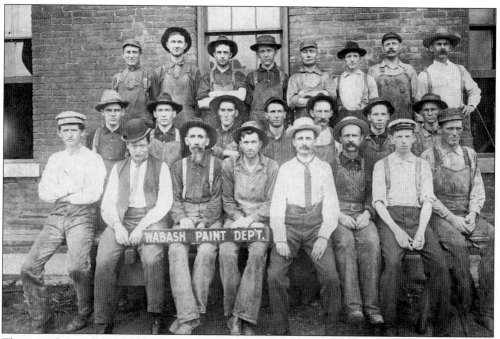

WABASH PAINT DEP'T.

This is a photo of the workers at the Paint Department of the Wabash Railroad c. 1900. They painted numbers on the cars, as well as whatever else the railroad needed to have painted. They worked out of the Wabash roundhouse off Lindell. (From the author's collection.)

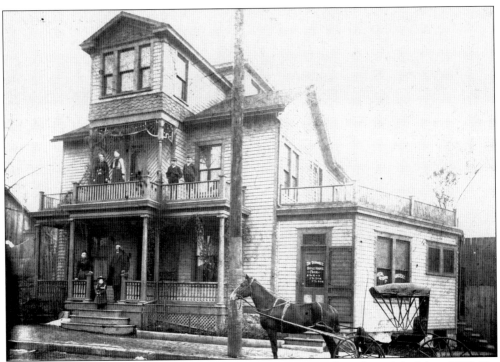

This photo is of Dr. Richard Schmidt's residence at 1203 Broadway (near Maple), c. 1900. Dr. Schmidt operated his office and a private hospital from this house. There was a sign in one of the windows stating "Special attention to surgery." One would certainly hope so! The doctor's horse and buggy call attention to the era when house calls were a large part of a physician's schedule. (From the author's collection.)

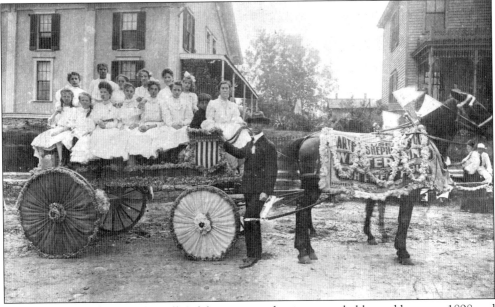

This is a float from one of the Fall Celebration parades; it was probably used between 1898 and 1903. The parades were the kick-off event for the fall festivals. (From the author's collection.)

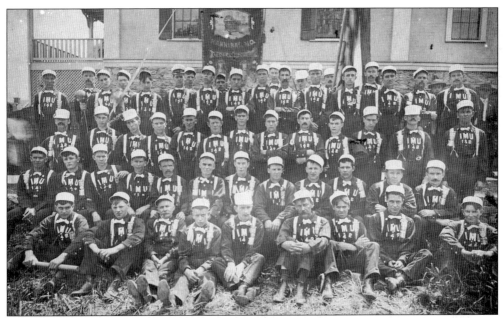

The members of the Iron Moulders Union local #142 of Hannibal posed for this group photo c. 1900. The union members had their own uniforms, caps, and banners. The occasion for this photo was probably a parade. (From the author's collection.)

This is a classic photo of Hannibal's best-known landmark. Samuel Langhorne Clemens, better known as Mark Twain, spent his boyhood years in this house. This photograph shows the home as it appeared in 1900, long before it became the shrine that it is today. The photographer, C.R. Martin, produced Hannibal's first picture postcards and used this view of the home on some of his first cards. (From the author's collection.)

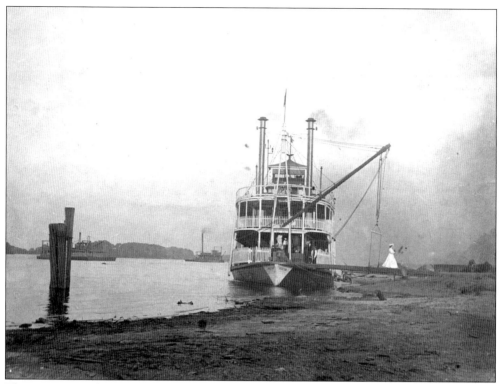

The steamer Uncle Sam made a striking photo when docked at the Hannibal riverfront in this c. 1900 image. The Mississippi riverboat, which figured so prominently in Hannibal's very early years, is part of the official city seal. (From the author's collection.)

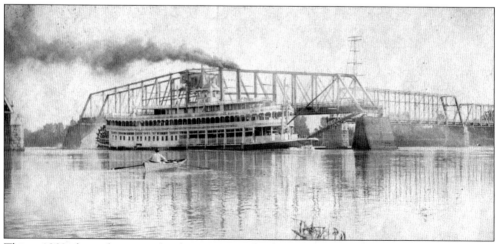

This c. 1903 photo shows another boat, a sternwheeler, coming through the opened swing span of the Wabash Bridge. What an impressive sight those old paddle-wheel riverboats must have been, gliding through the water with a thick head of black smoke trailing behind. (From the author's collection.)

This 1900 photo shows the old Presbyterian School Building at Fifth and Church, which served as Hannibal's public library at the time of this photo. In 1901 the building would be razed, and the present Garth Public Library would be built on the site. This photo was printed from an old glass plate negative in the author's collection.

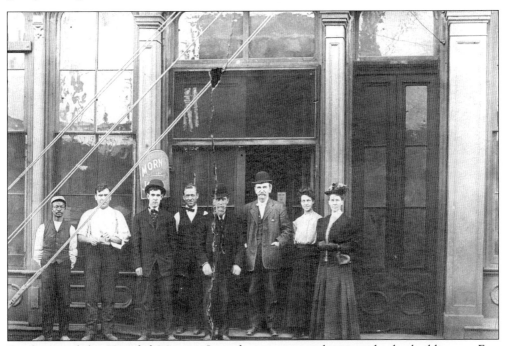

Employees of the *Hannibal Morning Journal* newspaper gather outside the building on East Broadway, *c.* 1900. This building was known as the RoBards Building. It would be razed in the 1960s. The *Morning Journal* newspaper would be merged into the *Hannibal Courier Post* in 1918.

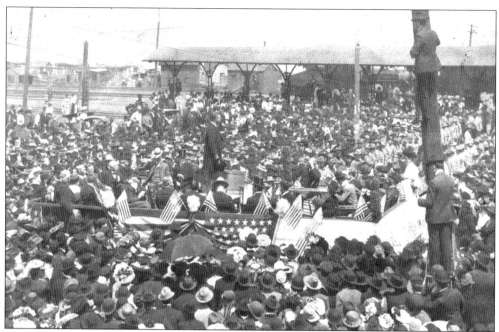

President Teddy Roosevelt visited Hannibal on April 29, 1903. This photo shows Mr. Roosevelt delivering a speech at Union Depot to a packed audience. Notice the fellows climbing the telephone pole for a better look. (From the author's collection.)

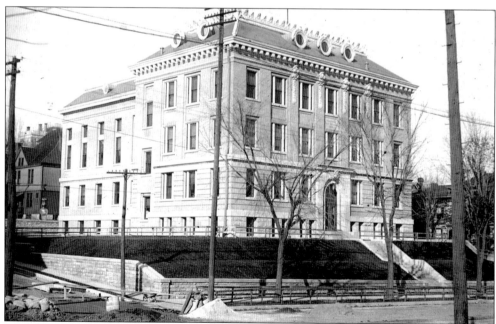

This 1904 photo by Anna Schnitzlein shows the stately old Hannibal High School just after it was completed. Located on Broadway at Eleventh Street, it served as a high school until the present one was dedicated in 1934. The building was torn down in 1974 and replaced by a high-rise. Former students recalled that the gym was located on the top floor, and when playing basketball, one had to be careful to dodge the roof beams. (From the author's collection.)

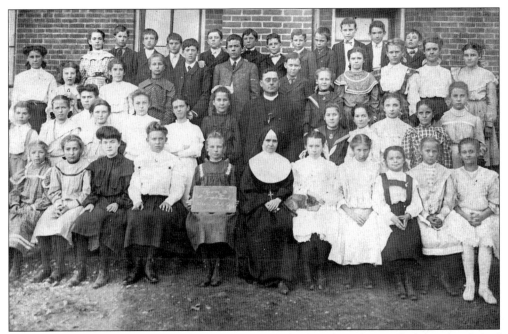

Catholic education has had a long history in Hannibal. This photo (c. 1905) shows the class of room #2 of the old St. Joseph's Academy. The school was located in the 1100 block of Broadway. (From the author's collection.)

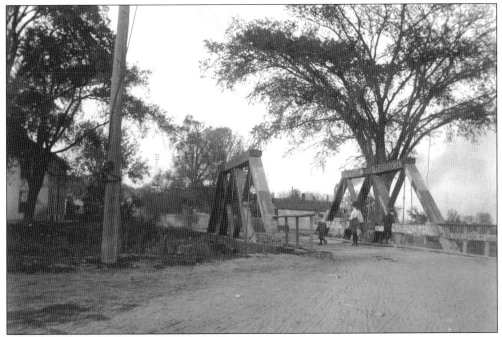

This photo shows Market Street looking east toward town with the Minnow Creek Bridge in the foreground, c. 1905. The bridge is long gone. Just beyond the bridge on the right is the present site of the Hannibal Homestore (2002). Anna Schnitzlein, the photographer of this picture, lived in a house just to the right of this photo. (From the author's collection.)

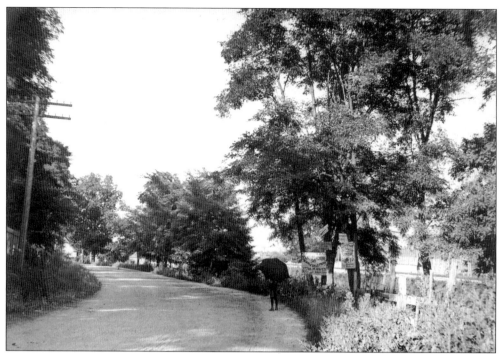

This is a photo of Market Street looking east, where a pedestrian has stepped out for what appears to be a leisurely stroll. Market Street was but a dirt road at the time this photo was taken around 1905. (From the author's collection.)

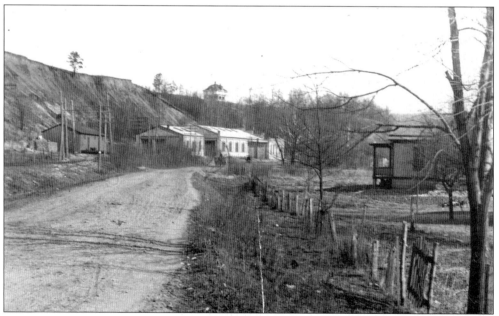

This photo (c. 1910) shows the streetcar barn of the Hannibal Electric Railway out along Market Street. The building, now demolished, was used much later by the Hannibal-Quincy Truck Lines. The house atop the bluff belonged to Sinclair Mainland, owner of the Hannibal Electric Railway. This photo was taken by Anna Schnitzlein and is from the author's collection.

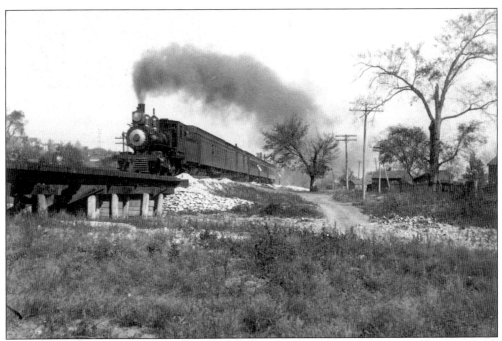

Here is another Anna Schnitzlein photograph of a passenger train crossing the Minnow Creek Bridge near Market Street, c. 1905. (From the author's collection.)

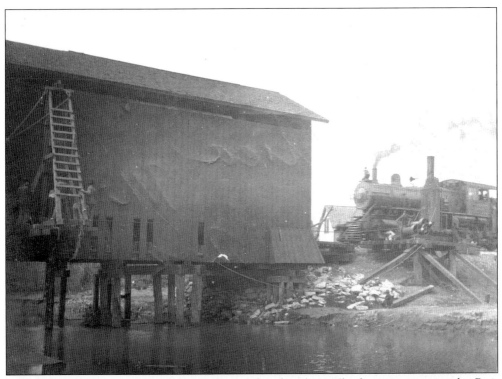

Anna Schnitzlein is also the photographer of this shot (c.1905) of a train entering the Bear Creek covered railroad bridge, near Market Street as well. (From the author's collection.)

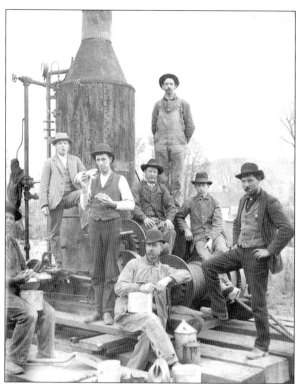

This photo pictures a railroad work crew on lunch break. They are posed around a steam-powered apparatus, which was located at the covered railroad bridge over Bear Creek near Market Street. The photo dates from around 1905. (From the author's collection.)

At the beginning of the 20th century, there were a number of exploratory operations to find oil and natural gas in the area, all of which were unsuccessful. This Anna Schnitzlein photo shows one of these attempts between Market Street and Lindell Avenue, between 1905 and 1910. Notice the people standing around waiting for something to happen. The houses in the distance front Market Street. (From the author's collection.)

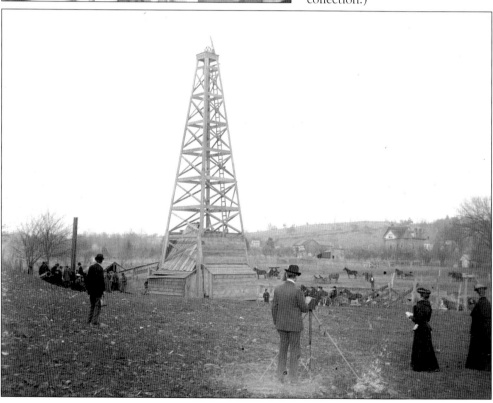

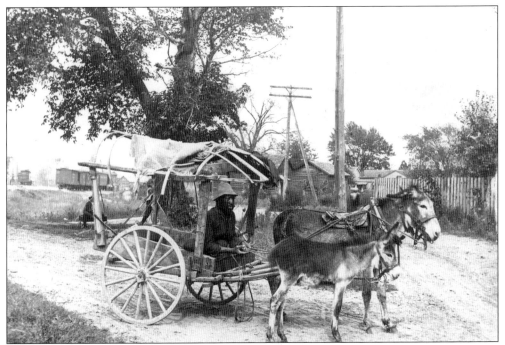

"Old Hannibal" was a familiar sight to the locals at the turn of the last century. Having lost both of his legs, he got around town in a homemade cart pulled by a mismatched team of mules. There were no governmental programs at that time for the needy; Old Hannibal made his living by caning chairs. He died in 1909. This photo by Anna Schnitzlein was taken just off of Market near the Minnow Creek Bridge, c. 1905. (From the author's collection.)

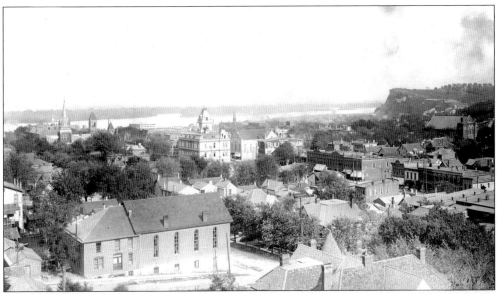

This bird's-eye view of Hannibal was taken by Anna Schnitzlein around 1905. Looking towards Lovers Leap, it was taken from the old Central School tower. At lower left is the Eighth & Center Church. In the center of the photo is the old Federal Building with the river in the background. (From the author's collection.)

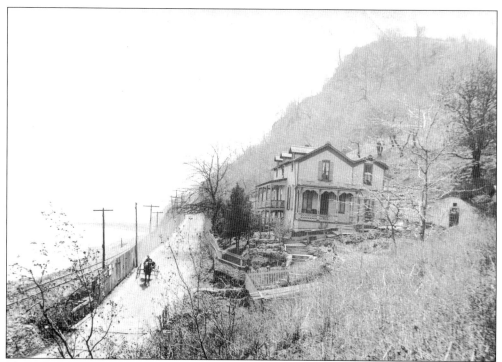

This 1905 Anna Schnitzlein photo shows a view of River Road, north of town and looking back towards town. Note the board fence between the road, the railroad tracks, and the river. (From the author's collection.)

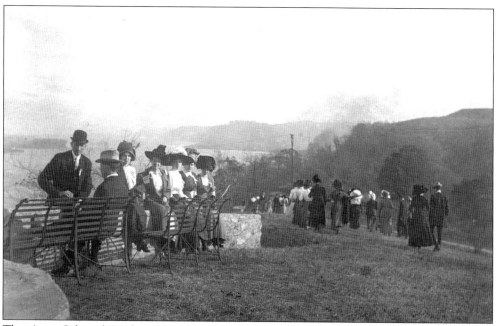

This Anna Schnitzlein photo shows the new Riverview Park after its opening in 1909. Notice how open and free of trees the park appears at that time. In the beginning, the park was accessed by a trail that led up from River Road. (From the author's collection.)

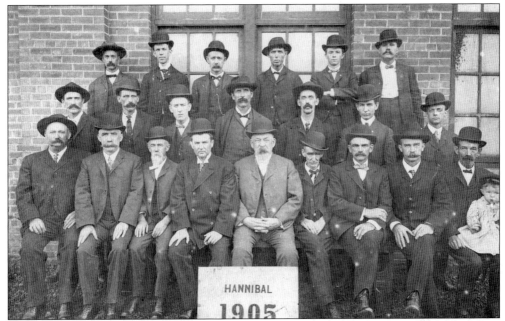

The foremen of the Burlington Railroad pose for a picture in 1905. Pictured here, from left to right, are the following: (first row) Bill Dalton, Tom Higgins, Chillion, unidentified, Ike Wellborn, Johnny Johnson, unidentified, Clay Johnson, Fred Starks and grandson; (middle row) unidentified, Charley, Schmidt, Carl Zink, Tony Holmes, unidentified, unidentified, and Foster; (third row) none identified. (Photo courtesy of Archie Hayden.)

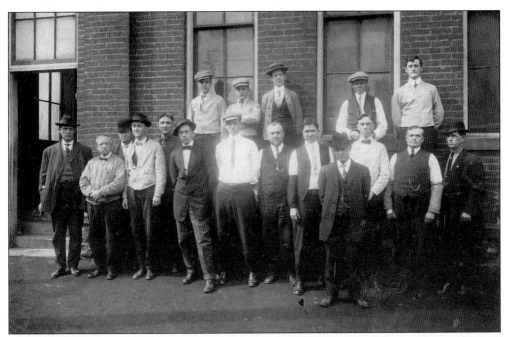

This is a group photo of workers of the Wabash and MK&T Freight House, taken in front of the building at the foot of Broadway, c. 1907. The building would be removed in 1962 for a parking lot. (Courtesy Archie Hayden.)

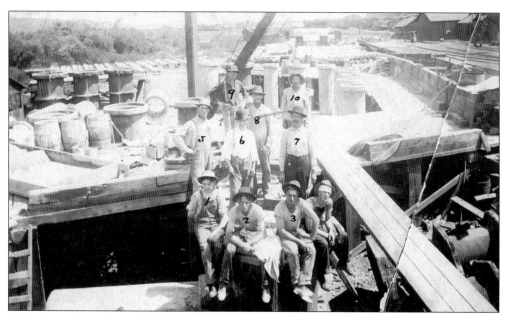

This view shows the concrete plant, which was located in the railroad yards. This plant manufactured the pilings, culverts, and other concrete forms the railroad needed along their tracks. Identified are the following: (1) C.A. Brown, (2) J.F. Kachanbaugh, (3) L.Siglar, (4) J. Frans, (5) C. Harris, (6) A. Rouse, (7) A.S. Brown, (8) Geo. Fuqua, (9) Jno. Treister and (10) A.A. Cox. The photo was taken August 21, 1909. (From the Hurley and Roberta Hagood collection.)

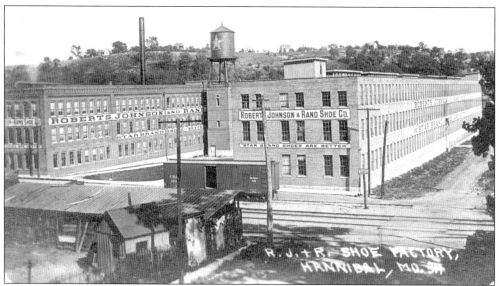

The Roberts, Johnson & Rand Shoe Factory employed nearly 5,000 workers in its heyday. That was when the population of Hannibal was just over 20,000. Roberts, Johnson and Rand, better known as the Star Shoe Company, later became International Shoe and closed its doors for good in the 1960s. The old factory stood on Collier, between Sixth and Seventh Streets. It was demolished after the flood of 1993. This real photo postcard dates from 1908. (From the author's collection.)

Edmond Jones ran a grocery store at 315 Market Street in the early 1900s. He lived upstairs, over the grocery. Jones later sold insurance. This real photo postcard of his store dates from around 1908. (From the author's collection.)

This 1910 real photo postcard shows another grocery; that of John Loetterle, which was located at the corner of Fourth and Palmyra Avenue (now Mark Twain Avenue). Mr. Loetterle stands outside his store with his two children. Notice the grocery delivery wagon. (From the author's collection.)

This photo (c. 1907) shows what visitors to Hannibal might have seen when they got off their train and stepped out of the depot. To the left, across from the depot, is the Kettering Hotel. Just beyond the depot on the right is the Digel Saloon, and the Mark Twain Hotel is beyond that. Streetcar tracks run down the middle of Main Street. If you look carefully on the left side of the street in the background, you will see the light tower at Main and Church. There were 11 of these tall steel towers with powerful carbon arc lights mounted on them. These towers lit an area of several square blocks. A worker climbed these towers daily and replaced the burnt carbons with fresh ones. They were removed around 1910 as conventional street lights were installed. (Courtesy of Archie Hayden.)

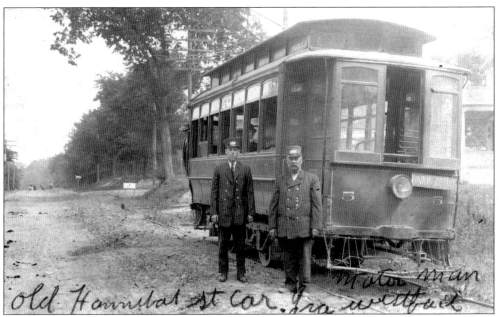

old Hannibal St car. Ira westfall *motor man*

This photo postcard captures one of the old streetcars of the Hannibal Electric Railway Co. It was taken along Fulton Avenue. The motorman is identified as Ira Westfall. The first streetcars were drawn by mules and began operation in 1878. The electric cars replaced the mule-drawn ones in 1890. The streetcars could not compete with the auto and the bus, and service ended in 1930. The cars went to the scrap yard, and the tracks were pulled up in the 1930s. This photo dates from around 1909. (From the author's collection.)

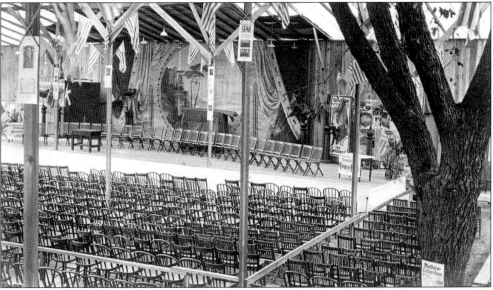

The Chautauqua was an event, held annually from 1906 through 1929, that Hannibalians looked forward to. It brought religious, educational, and political speakers, as well as celebrities and entertainers. It was part circus, part revival, part theater. The Chautauquas made the circuit of a number of cities, staying two weeks at each location. This real photo postcard, *c.* 1908, shows the inside of the Chautauqua tent in Central Park. (From the author's collection.)

Hannibal is truly a city of hills. This 1910 photo looks out towards the Mississippi River and Lovers Leap from the vantage point of Grace Street. (From the author's collection.)

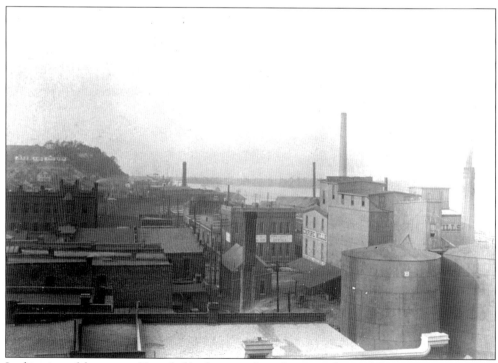

In this view of downtown Hannibal looking out from the upper floors of the Mark Twain Hotel, one can see Hannibal National Bank, the Wabash Freight Office, Empire Mills, and the storage tanks behind the Mills. This photo dates from about 1910. (Courtesy of Hannibal Public Library.)

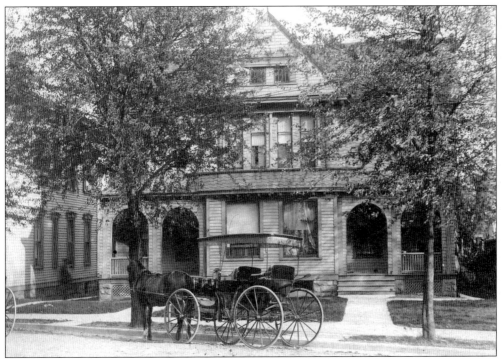

The duplex at 1117–19 Center Street has not changed too much from its appearance in this 1910 real photo postcard, although the horse and buggy are long gone. (From the author's collection.)

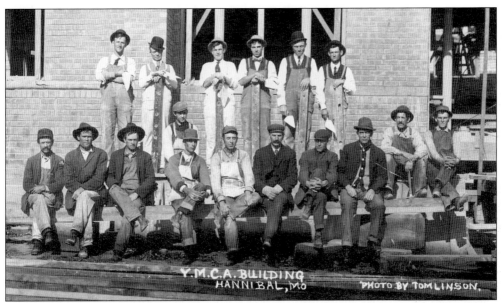

This is a photo of the YMCA Building construction at Fifth and Center in 1911. The YMCA Building served Hannibal well for three generations. It was vacated when the new YMCA building opened in 1983 and sat empty for nearly 20 years. It is presently (2002) being renovated by a church group for their use. (From the author's collection.)

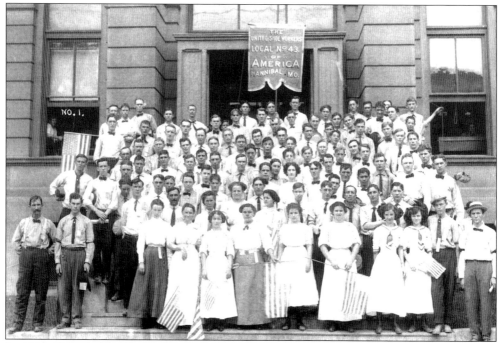

In 1911, Hannibal held a huge Labor Day parade. Afterwards, each union group posed for a photo in front of the old Federal Building by local photographer Herbert Tomlinson. This is a group photo of United Shoe Workers Local #43. (From the author's collection.)

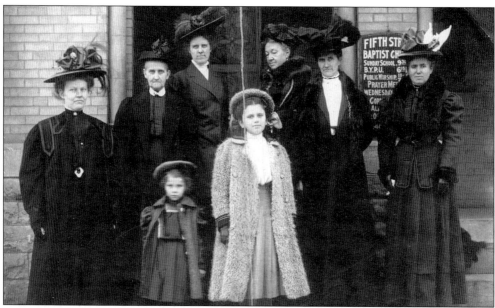

A group of women from Fifth Street Baptist Church posed for this c. 1912 photo, and are identified, from left to right, as follows: (front row) Mrs. Martha Berry, Mae Berry Drennan, and Gladys Tucker; (second row) Mrs. Bibb, Mrs. Lilly Graham, Mrs. A.R. Levering, Mrs. Dameron, and Mrs. Tucker. Mrs. Levering's husband built and gave to the city its first public hospital, Levering Hospital. (From the author's collection.)

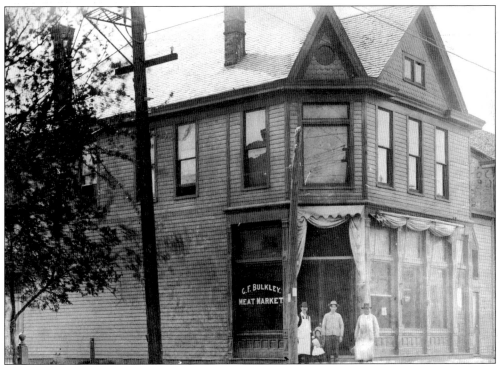

This is a 1912 photo of the Charles F. Bulkley Meat Market on the south side. The market was located at the corner of Union and School Streets. Mr. Bulkley stands at the far left, with his daughter next to him. The building was torn down around 1994. (From the author's collection.)

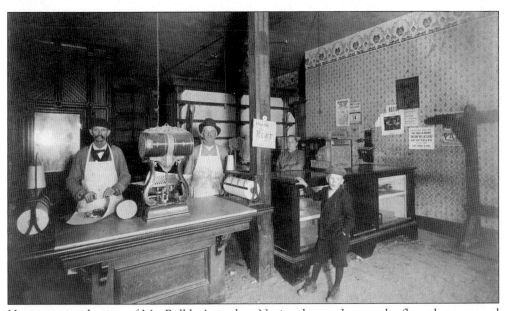

Here is an inside view of Mr. Bulkley's market. Notice the sawdust on the floor that was used to soak up the blood and meat juices. This photo also dates from 1912. (From the author's collection.)

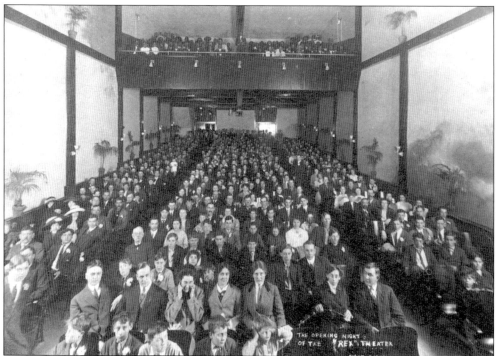

The "moving picture show" was big news in the early 1900s. Here is an interior of one of Hannibal's early theaters, the Rex, on opening night, April 4, 1912. The Rex boasted a "Magic Mirror Screen" and seating on the main level for 500, with an additional 150 seats in the balcony. Like many early theaters, the Rex was segregated; black patrons had to sit in the balcony. Notice some of kids in the front rows are holding their ears.... it must have been some show! The Rex was located on North Main Street. (From the author's collection.)

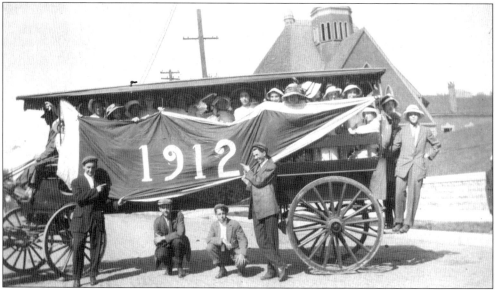

The 1912 class of Hannibal High School poses for an informal portrait on Broadway. Pilgrim Congregational Church is in the background. (From the author's collection.)

The original location of the swing span of the Wabash Bridge was at a very treacherous point in the river. Due to the swiftness of the current, a number of riverboats had been wrecked trying to pass through. On September 6, 1913, the swing span of the bridge was moved one span closer to the Missouri shore where the current was safer. New bridge piers had already been built underneath, and the actual moving of the two spans was done in one day. (Photo courtesy of Kathy Threlkeld.)

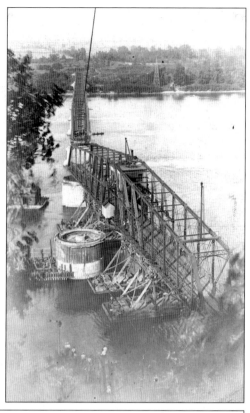

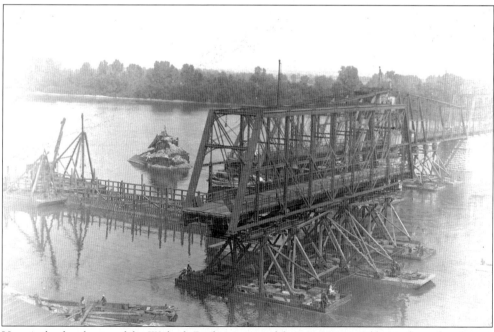

Here is the fixed span of the Wabash Bridge, removed from its piers, and being floated on barges to its new location during the moving of the swing span on September 6, 1913. (Courtesy Kathy Threlkeld.)

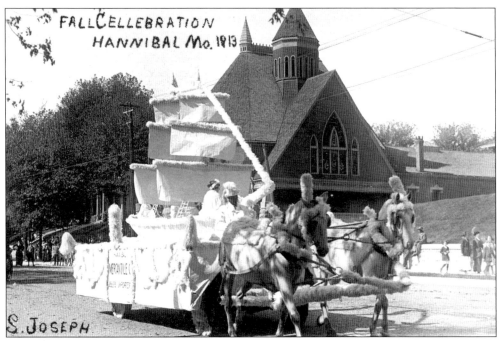

This photo shows the horse-drawn float for Hannibal Mercantile Company in the Merchants' Parade during the 1913 Fall Celebration. Hannibal Mercantile was owned by a Syrian man, Solomon Joseph. Joseph came to Hannibal in 1900, became a U.S. citizen, and operated Hannibal Mercantile for 40 years. He deeply loved his new country, and gave a U.S. flag to the City to fly in Central Park. (Photo from the author's collection.)

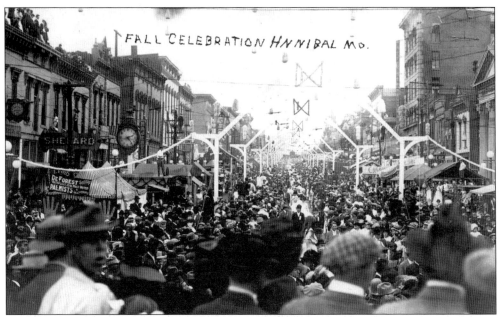

The old fall celebrations drew thousands of people. The 1913 festival was the largest one, drawing over 75,000 people during the four-day run. Here is a photo of the crowds at the 1913 festival taken in the 200 block of Broadway. (From the author's collection.)

This young lad, enjoying the 1913 festival, looks like he could have stepped right from the pages of *Tom Sawyer* or *Huckleberry Finn*. Hannibal's First Regimental Band is performing on the platform, and Hannibal National Bank is visible in the background. (From the author's collection.)

This was Trinity Episcopal Church's booth for the 1914 Fall Celebration. The church sold dinners and refreshments as a fund raiser. Alice Richards, a worker in the booth during the festival, reported that the church cleared $175 profit from sales. That was quite a sum, considering dinners were 25¢ and coffee 5¢! (From the author's collection.)

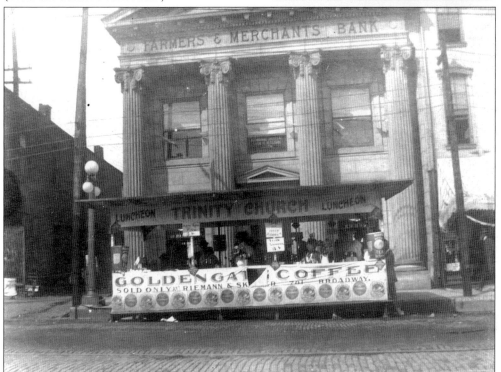

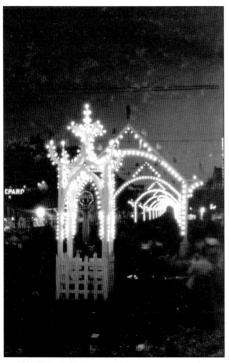

This is a nighttime view of the lighted street decorations during the 1914 Fall Celebration. Thousands of light bulbs were used in the decorations. After one of the festivals, the Board of Public Works sold off all of the light bulbs. It was reported that they sold out on the white and the clear bulbs, but no one wanted to buy the red ones! (From the author's collection.)

This is a group photo of the 1915 graduating class of Hannibal High School after receiving their diplomas. The ceremonies took place in the auditorium of the old Hannibal High School on Broadway. (From the author's collection.)

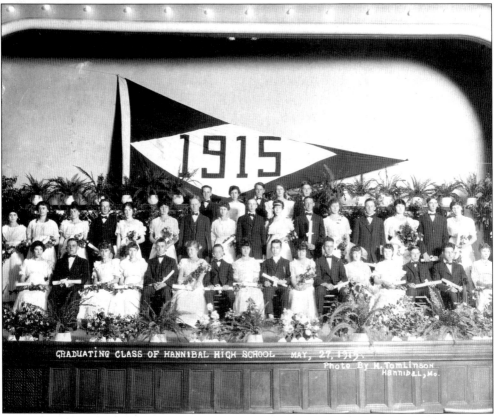

GRADUATING CLASS OF HANNIBAL HIGH SCHOOL MAY, 27, 1915.
Photo By H. Tomlinson
Hannibal, Mo.

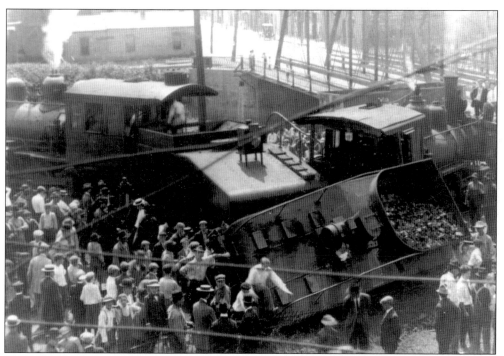

This photo was snapped very soon after a train wreck right behind the Depot around 1915. Note that the two engines are still letting off steam. The Main Street Bridge over Bear Creek is visible in the background. (Courtesy of Archie Hayden.)

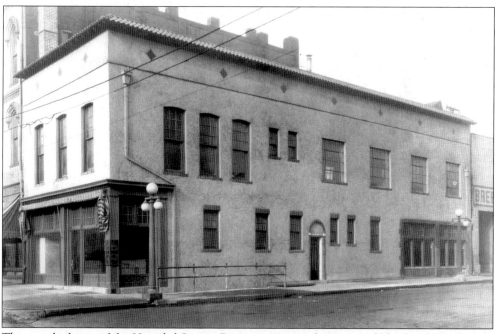

This was the home of the *Hannibal Courier Post* newspaper at the corner of Third and Broadway as it appeared *c.* 1915. Founded in 1838, the *Courier Post* is Missouri's oldest newspaper. They would relocate to their present address of Third and Center in 1952. (From the author's collection.)

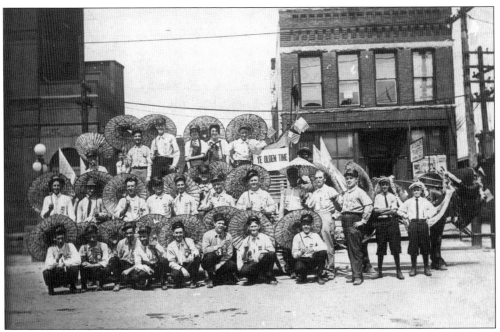

This merry-looking bunch—complete with oriental parasols—posed for a group photo after an unidentified parade. Their identity is unknown, but they are all wearing fraternal ribbons. The photo dates from around 1915, and was taken on East Broadway. (From the author's collection.)

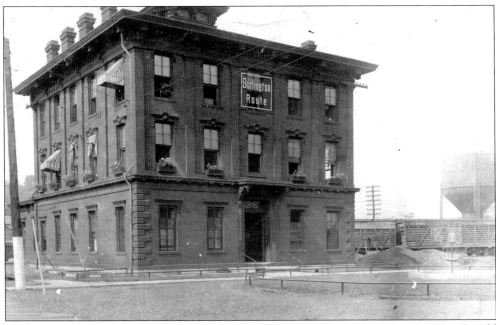

This c. 1915 photo shows the old Hannibal-St. Jo office building in the railroad yards. The old water tower in the yards is visible at right. Note how neat and tidy this building is kept, with the flower boxes in the windows. The old office building, built before the Civil War, survived almost all of the other structures in the railroad yards. It was torn down in 1995. (From the author's collection.)

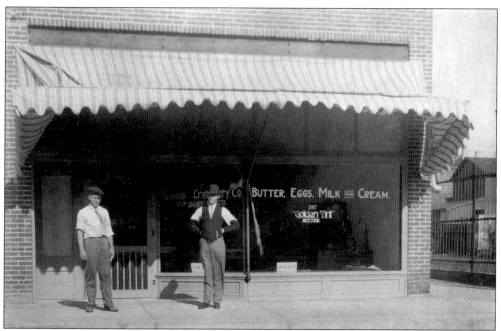

This is the Hannibal Creamery that was located at 108 South Seventh. John Shackelford was the proprietor. The photo dates from 1916. This building still stands (2002). (From the author's collection.)

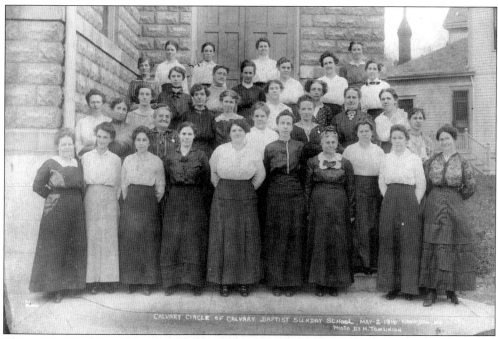

This is a group photo of the Calvary Circle Sunday school class of the Calvary Baptist Church at Hope and Willow Streets. This looks to be a very happy group. The photo was taken May 2, 1916, by Tomlinson Studio. (From the author's collection.)

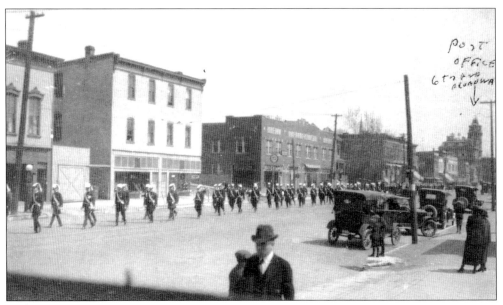

This is a view of the Knights Templars' parade on Broadway in 1916. This panoramic sweep takes in the 600, 700, and 800 blocks of Broadway. (From the author's collection.)

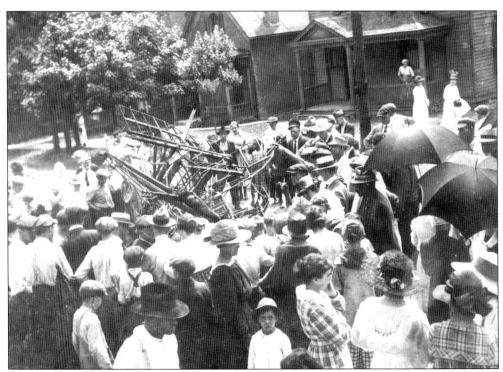

In 1919, a plane came to Hannibal dropping leaflets advertising a truck caravan. The plane, a canvas covered biplane, caught fire in the air and tried to make an emergency landing on Lyon Street near Tenth. Unfortunately, the pilot was burned to death before rescuers could pull him from the burning plane. Here, a crowd of onlookers gathers around the wreckage. (From the author's collection.)

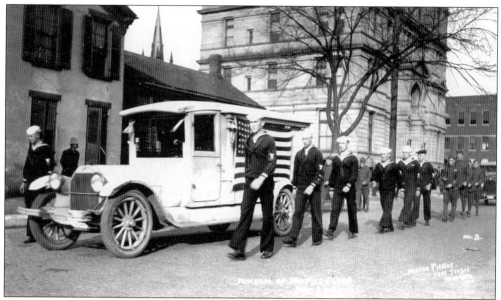

In November of 1919, the remains of Francis Flood, a Naval seaman and Hannibalian were returned to Hannibal for permanent burial. He had previously been buried in a cemetery in Scotland. Here is the funeral procession for Flood, which was held on November 23. The hearse is being given a military escort. Flood was buried in Mt. Olivet Cemetery. (From the author's collection.)

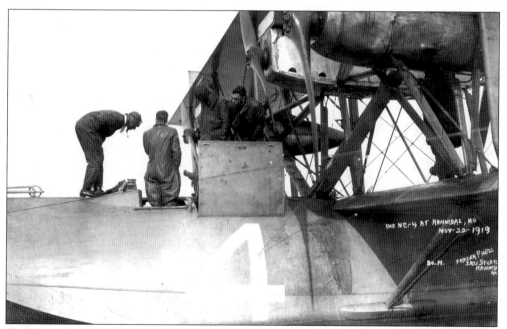

On November 22, 1919, the famous U.S. Navy plane NC-4 arrived in Hannibal for a visit. The NC-4 was one of the U.S. Navy planes that completed a transatlantic crossing earlier in the year. As the plane landed on the river, one of the its pontoons struck a sewer pipe, and the plane was grounded several days for repairs. Here is a close-up shot of the NC-4 taken by Frazer Studios. (From the author's collection.)

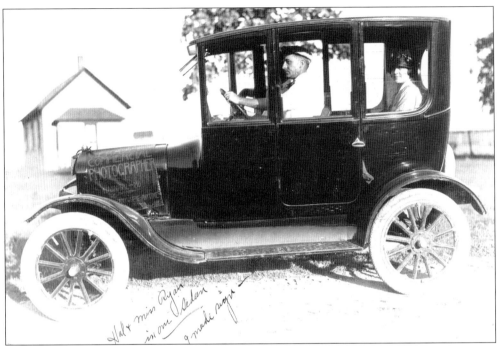

This Ford Model T sedan belonged to Hal and Jean Frazer of Frazer Studio. Note the advertising sign on the hood. Jean Frazer writes on photo, "Hal and Miss Ryan in our sedan." Notice also that Miss Ryan's dress is caught in her door! The photo dates from c. 1920. (From the author's collection.)

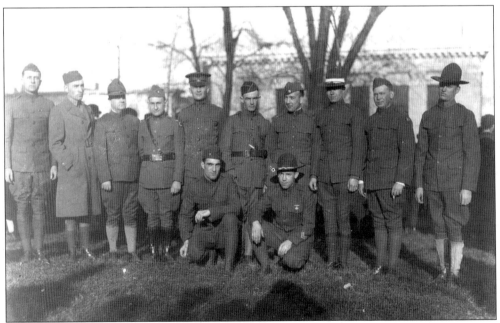

This group of World War I veterans posed for their picture in Central Park. Much later, a monument would be placed in the park honoring Hannibal's servicemen in the two world wars. Th photo was taken around 1920. (From the author's collection.)

Here is a photo of Levering Hospital at 1734 Market, as it appeared around 1920. The hospital, opened in 1903, would be expanded several times before it merged with St. Elizabeth's Hospital in 1988 to become Hannibal Regional Hospital. (From the author's collection.)

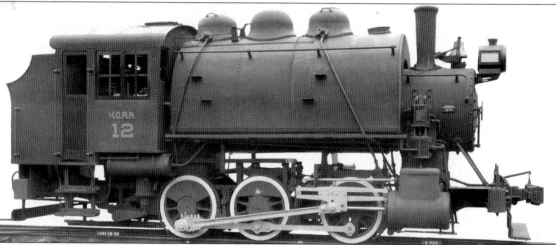

This is a builder's photo of Engine #12 of the Hannibal Connecting Railroad. It shows the engine as it looked when it was completed in June 1923. The Hannibal Connecting Railroad ran between Hannibal and the Atlas Cement Plant just a few miles south of city limits. (From the author's collection.)

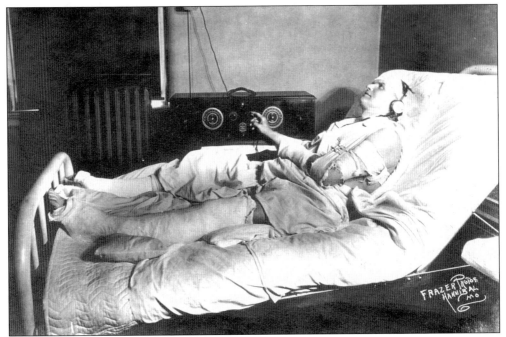

Radio was all the rage in the 1920s. This 1924 photo shows a patient at Levering Hospital enjoying a radio program from his bed. The radio set is an RCA Radiola Superhetrodyne battery set. The patient is unidentified. (From the author's collection.)

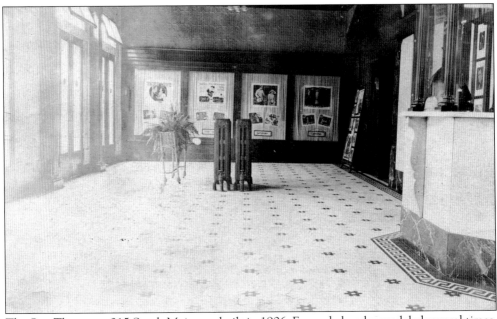

The Star Theater at 215 South Main was built in 1906. Expanded and remodeled several times, the theater closed in the 1960s. It then became a nightclub, which eventually closed. The building had badly deteriorated and was threatened with demolition before being purchased in 2001. It is presently being restored to its former glory. This real photo postcard shows the lobby as it looked in the 1920s. (From the author's collection.)

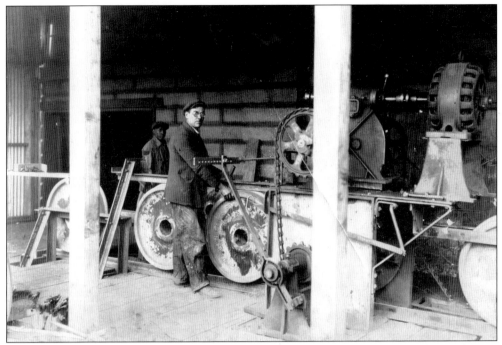

Here is a worker at the Hannibal Car Wheel operating a wheel-cleaning machine around 1925. Hannibal Car Wheel was located at 1200 Collier Street. They cast the steel wheels used on railroad cars. (From the author's collection.)

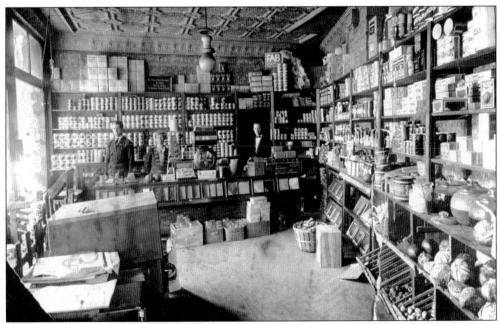

Here is the interior of the James Grocery at 1200 Market in 1925. It was owned by Orville and Eric James. The old groceries carried a little bit of everything, but only one or two brands. Self-service shopping was unheard of; you told the grocer what you needed and he would get it off the shelf for you. (Photo courtesy of Hannibal Public Library.)

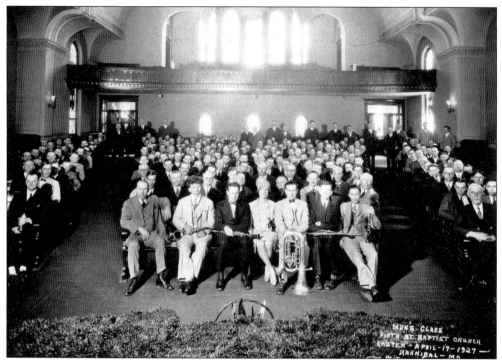

The men's Sunday School classes of Fifth Street Baptist Church gathered in the sanctuary on Easter Sunday 1927 for this group photo. The church had a sizeable Sunday School at that time, and the church had its own orchestra. The woman in the center of the middle front pew is Mary LaDue, who served as church organist for over 50 years. Seated at front, far right, is Dr. J.N. Baskett, Sunday School superintendent, and the pastor, J.B. Trotter, is seated at far left. (From the author's collection.)

A convention of cleaners met in Hannibal in June of 1928. Here the assembled group poses for a picture in front of Lewis Cleaning Company at 1415 Market. (From the author's collection.)

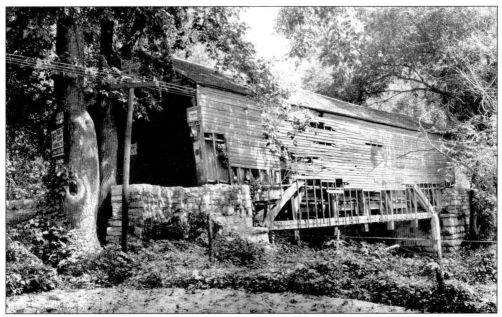

This 1920s photo shows the deteriorated condition of the old covered bridge at Oakwood. The Frazer Studio photo depicts the bridge prior to its removal. The sign with the dark circle that is tacked up to the right side of the one end designates that this bridge was part of the Red Ball Highway. Before the highway numbering system was adopted, highways were marked with symbols such as the red ball. (From the author's collection.)

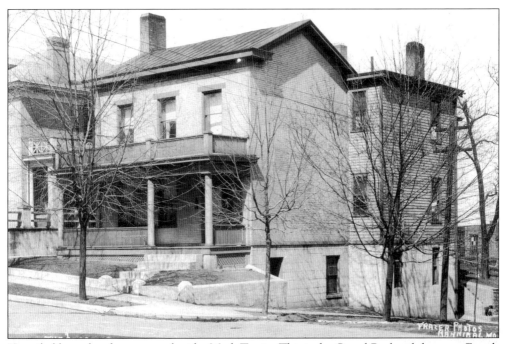

Hannibal has other famous sons besides Mark Twain. This is the Carrol Beckwith home at Fourth and Hill. The famous 19th-century artist was a native Hannibalian and was born in this home. It still stands today. This photograph dates from the 1920s. (From the author's collection.)

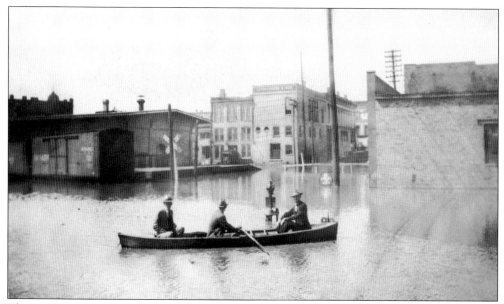

These men are out for a small excursion at the foot of Center Street during the flood of 1929. Visible above the boat in the background is the rear of Sonnenberg's Department Store, and to the right, partially hidden by boxcars, is the Wabash Freight House. (From the author's collection.)

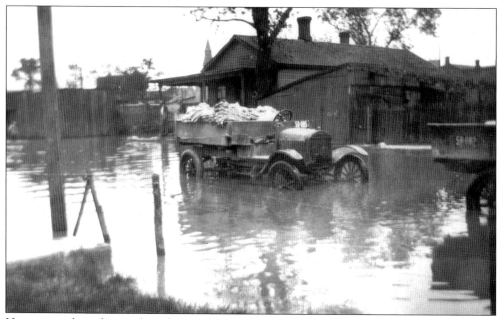

Here is another photo taken during the flood of 1929. This is a view of a very wet south Hannibal. The clock tower of Union Depot is visible in the background. (From the author's collection.)

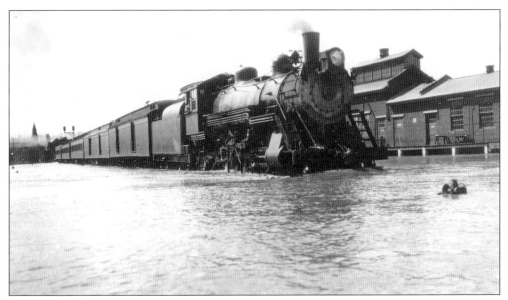

Here is a Burlington train making its way through the railroad yards in south Hannibal during the April 1929 flood. The tower of Union Depot is visible in the background. (From the author's collection.)

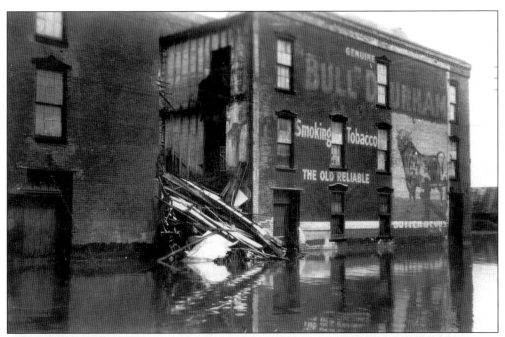

The many floods were hard on Hannibal's riverfront buildings. Here is one old building at the corner of Levee and Bird that suffered a collapse during the flood of 1929. This building had once served as a railroad depot before the construction of Union Depot. (Courtesy of Archie Hayden.)

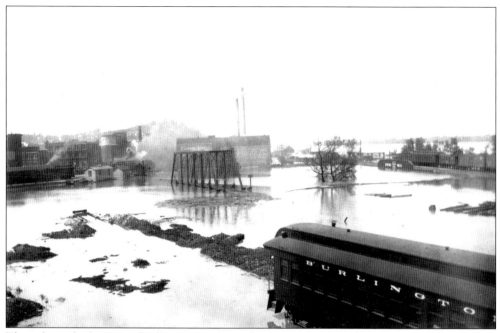

This photo looks towards downtown from the railroad yards during the 1929 flood. A Burlington passenger car is pictured in the foreground, and the Bear Creek railroad bridge is in the distance. (From the author's collection.)

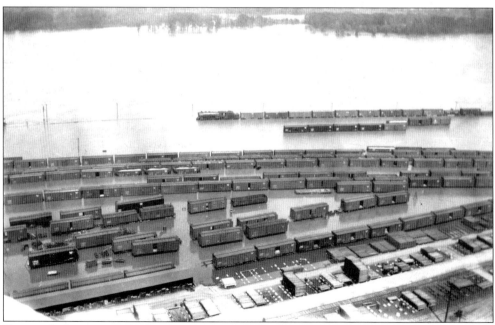

Here we look across the railroad yards and out over the river during the 1929 flood. Note the boxcars sitting in the yard. (From the author's collection.)

Three

HARD TIMES
AND WAR TIMES

1930–1945

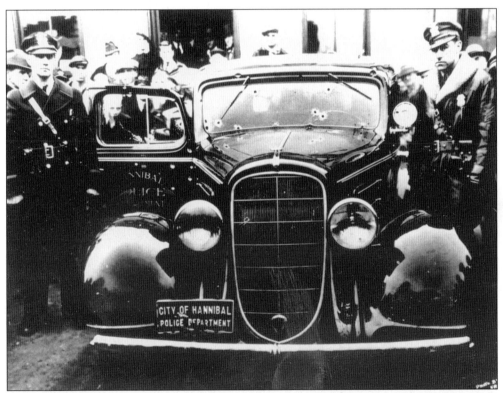

On January 9, 1934 the notorious outlaw John Dillinger and his gang were reported to be in the Hannibal area. They stole a car from Murphy Motors. A Hannibal police car was sent out after them on US 36, west of city limits, and was ambushed. The officers escaped unhurt, but their car was riddled with bullets. Here, posing with the damaged vehicle, are Police Chief William J. Schnieder on the left and Lieutenant J.O. Barker on the right. (From the author's collection.)

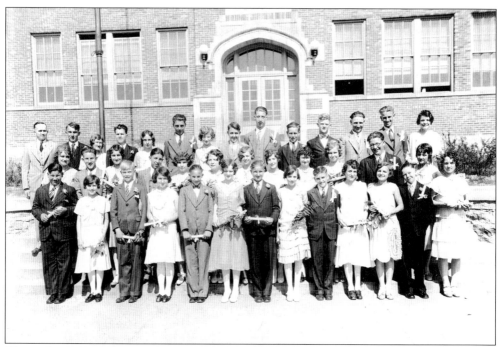

This is the 1930 graduating class of Stowell School. Stowell served as a Junior High School at that time. (From the author's collection.)

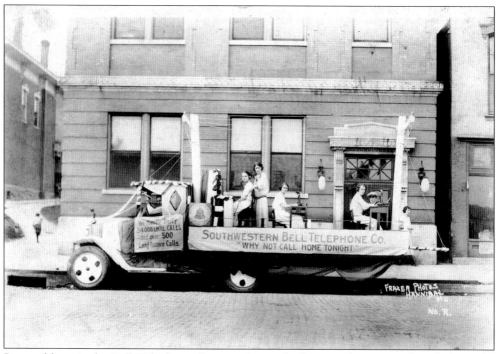

Pictured here is the Bell Telephone Company's parade float, used in an unidentified parade. The float is adorned with a full switchboard. It is parked in front of the Telephone Building on Broadway. This photo dates from around 1930. (From the author's collection.)

The identity of this young lady perched atop the car fender is lost to us now, but she sits in front of the Kroger Store at 716 Broadway. The photo is dated 1931. (From the author's collection.)

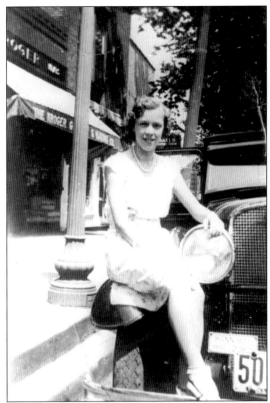

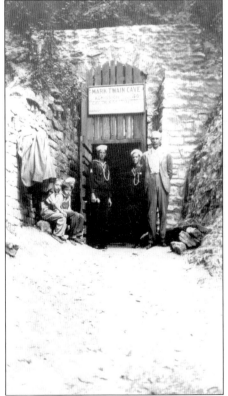

Mark Twain Cave has hosted many thousands of visitors over the years. Here Judge Cameron is pictured with two visitors, Sea Scouts B. Groom and G. Teichmann in July 1933. Judge Cameron owned and operated Mark Twain Cave from 1923 until his death in 1945. The identity of the boys is unknown; probably some local children that Mr. Cameron had befriended. He loved children and often let them play at the cave. (From the author's collection.)

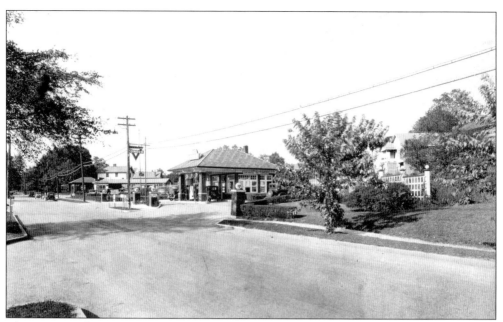

This Conoco filling station was located at the intersection of St. Marys Avenue and James Road in 1933. Note the neat and clean appearance of the station. (From the author's collection.)

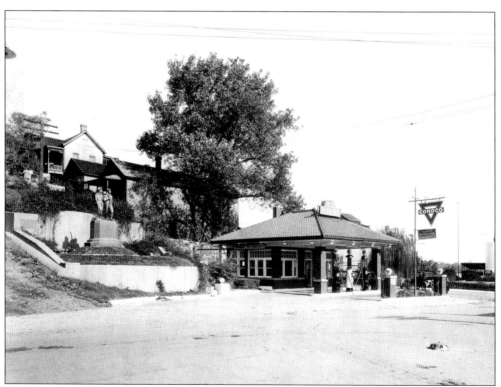

This is the Conoco filling station at the corner of North and Main Streets, also in 1933. John L. Mackey was the operator of this station. Notice the Tom and Huck Statue to the left of the station. (From the author's collection.)

"Floyd" drove the delivery truck for Lewis Cleaning Company at 1415 Market. Here he stands in front of his Dodge Brothers automobile in 1933. This photo was taken behind the cleaners. (From the author's collection.)

This recently constructed house at 105 Earl Street may look somewhat strange to us today, but its art-deco styling was very fashionable in 1935. The house still stands today, although it has had some remodeling over the years. (From the author's collection.)

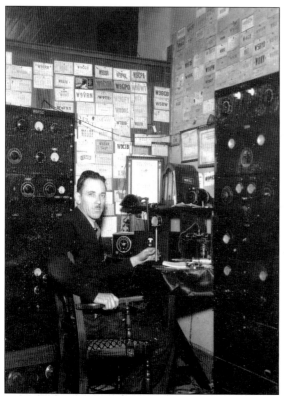

This is a photo (c. 1935) of ham radio operator Russell Huggins seated at his radio equipment. Huggins was a sign painter and his business was located at Sixth and Broadway. He had his radio equipment there at his shop. The number of QSL cards he has tacked up on the wall indicate he was quite serious with his hobby. (From the author's collection.)

This is a photo of the festivities opening the temporary Mark Twain Museum in the Hannibal Trust Building at Third and Broadway on April 25, 1935. As part of the year-long celebration of the centennial of the author's birth, a museum displaying artifacts from his life was set up. This was a forerunner of the permanent museum that would be built beside the Mark Twain home two years later. (Courtesy of Hannibal Chamber of Commerce.)

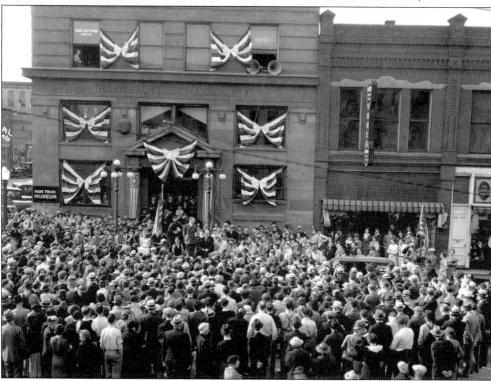

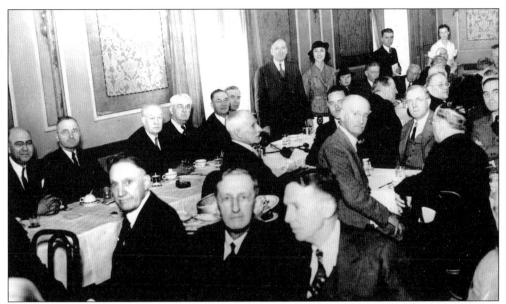

This photo shows the luncheon that was held in 1935 at the Mark Twain Hotel to commemorate the 100th anniversary of Mark Twain's birth. Seated second from the end at left is Harry S. Truman, who served as Missouri Senator at the time. Beside him are, from left to right, Missouri Governor Parks, Robert Clayton, Dulaney Mahan, and Ralph Budd. Standing are Ivan Yates and Nina Gabrilowitsch (Mark Twain's granddaughter). (Photo courtesy of Hannibal Chamber of Commerce.)

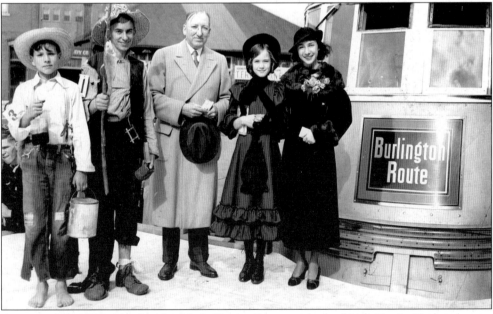

As part of the festivities for the Mark Twain Centennial, the Mark Twain Zephyr (a new streamlined Burlington train) was dedicated. The date was October 25, 1935. Traveling on the train were Nina Gabrilowitsch (Mark Twain's granddaughter) and Ralph Budd (president of the Burlington Railroad). Also shown in this photo are a costumed Tom Sawyer, Huckleberry Finn, and Becky Thatcher. (Photo courtesy of Hannibal Chamber of Commerce.)

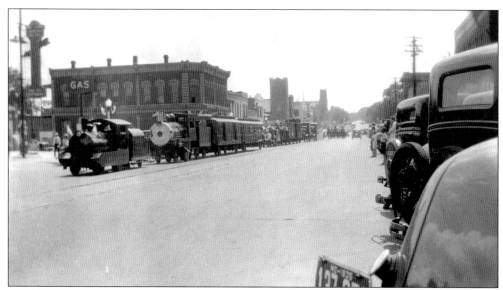

In June 1935, the railroads sponsored Railroad Week, a week of festivities and special exhibits to encourage the use of railroads for travel and shipping. The automobile and the truck were rapidly replacing the train in both of these areas, and this campaign was intended to win back some customers. A parade was held featuring miniature trains, which were driven down Broadway. Here is a photo of that parade, looking towards the 800 block of Broadway. (Courtesy of Archie Hayden.)

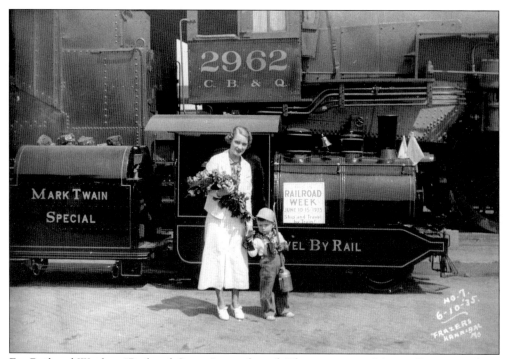

For Railroad Week, a "Railroad Queen" was elected. The winner was Marian Rupp, seen here standing with mascot Jack Firke. They are posed in front of a functional miniature train and a regular CB&Q locomotive. (Courtesy of Archie Hayden.)

This photo shows some sort of Masonic Lodge ceremony being held in Central Park around 1935. The Masonic Temple (originally the Park Theater) is at left, the old Park Methodist Church is in the center, and the former YMCA building is at right. The old Masonic Temple was razed in 1992, and the old Park Methodist Church was torn down in 1983. (From the author's collection.)

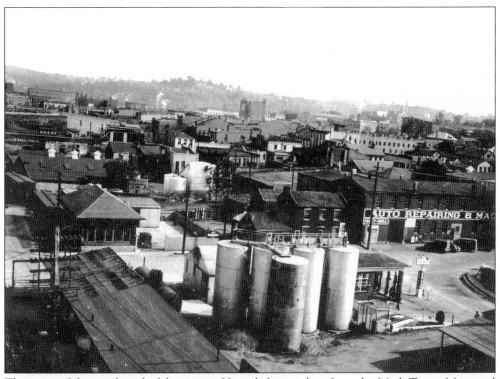

This view of the north end of downtown Hannibal was taken from the Mark Twain Memorial Bridge in September 1936. Almost all of the structures along the riverfront are gone today due to years of flooding and general deterioration. (From the author's collection.)

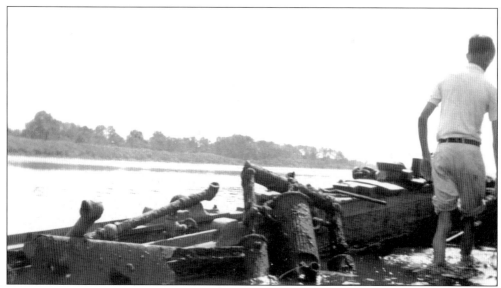

During the summer of 1936, the river dropped due to a long dry spell, and the submerged wreck of the Flying Eagle came into view for the first time since its loss in 1903. Here an unidentified man looks over some of the wreckage. The object sticking out of the water in the center of the photo is the boat's steam whistle. A light bulb recovered from the wreck still lit when plugged in. (From the author's collection.)

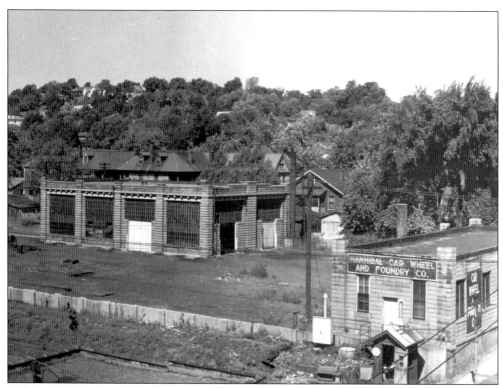

Here is a 1930s view of Hannibal Car Wheel and Foundry at 1200 Collier Street. The factory burned in 1936. (Courtesy of Archie Hayden.)

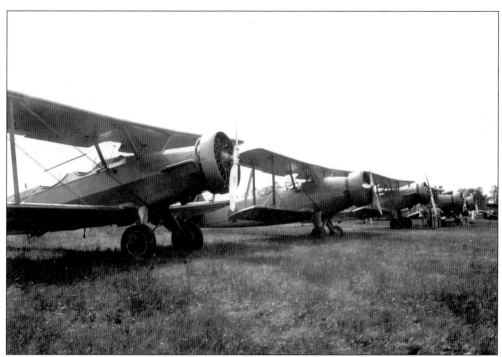

A model airplane contest was held at Long's Airport on June 6, 1937. As part of the activities, there was a fly-in of five planes from the Missouri National Guard. Those planes are pictured in this photo. There was also to be a parachute jump from a balloon on that day, but it was cancelled due to windy conditions. (From the author's collection.)

The Men's League Banquet of St. John's Lutheran Church was held on August 18, 1937. The event was held at Mark Twain Cave, and according to the newspaper account, a lot of fish were eaten that day. (From the author's collection.)

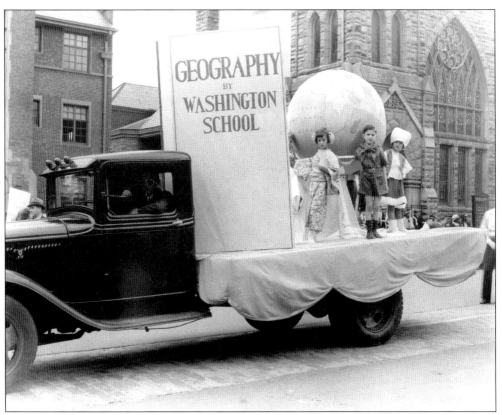

This is a parade float for Washington School. Washington School, located out on Market Street near Oakwood, closed in 1958 when it was absorbed into the Hannibal Public School system. This photo dates from the late 1930s. (From the author's collection.)

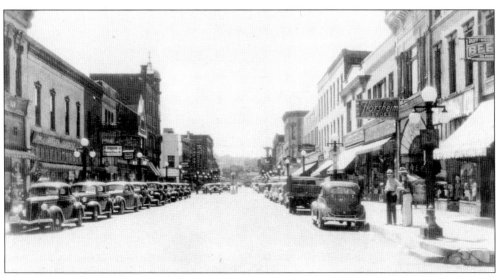

This is Main Street looking south from Center, as it appeared on a 1938 vintage photo postcard. The old three-globe streetlights would be replaced by 1939 with newer styles. (From the author's collection.)

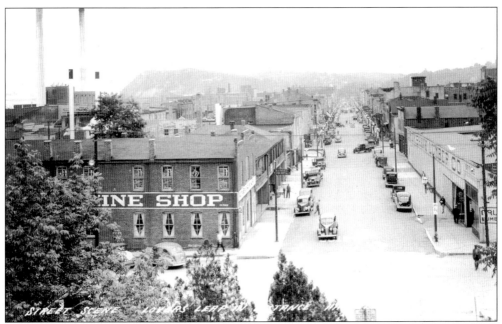

This 1938 view looks south on Main Street from Cardiff Hill. Cruikshank Lumber, visible at right, would survive into the 1960s. Due to the lumber company's proximity to the Mark Twain Home, a limestone wall was built behind the house to protect it in case of a fire at the lumber yard. The building at right (home of Murphy Motors in 2002) was a Packard automobile dealership in 1938. (From the author's collection.)

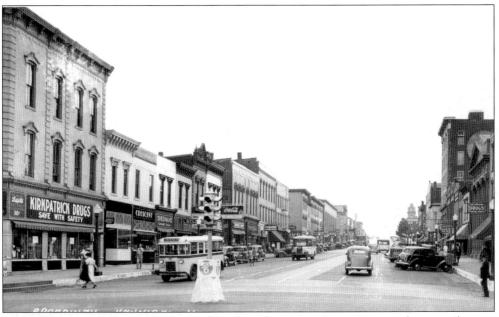

This 1938 postcard photo looks west on Broadway from Main Street. Two city buses can be seen in this photo. Hannibal's bus service, which began in the 1920s, ended in the late 1950s. Notice also the stop and go light. This was Hannibal's first traffic light, installed in 1925. (From the author's collection.)

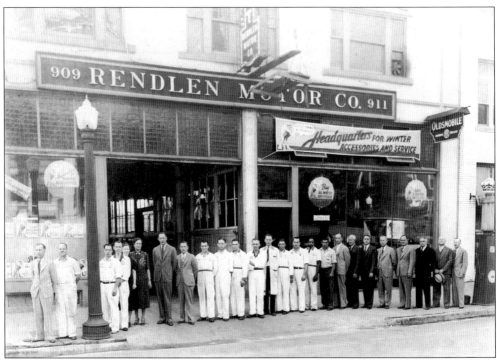

The employees of the Rendlen Motor Company at 909–911 Broadway posed for this group photo in 1938. Rendlen sold Chevrolet automobiles. (From the author's collection.)

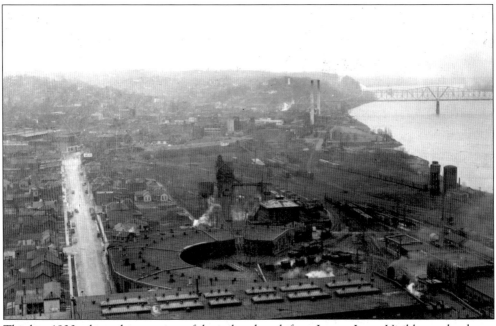

This late 1930s photo shows a view of the railroad yards from Lovers Leap. Visible are the shops, the roundhouse, the office building, and the coaling tower beyond. The coaling tower was pulled down in 1954, the shops and the roundhouse were gone by the early 1980s, and the old office building was torn down around 1995. (From the author's collection.)

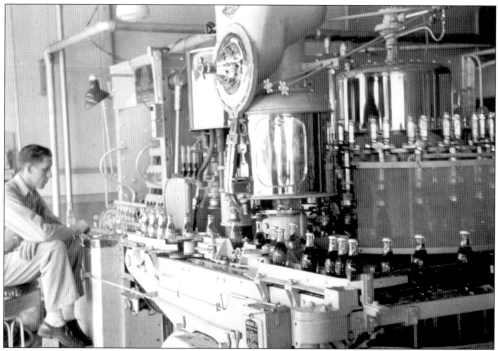

This is the bottling operation of Hannibal's Coca-Cola Bottling Plant, located in the 100 block of Center Street, as it appeared in the late 1930s. At that time, Coca Cola came in 6-ounce bottles and cost a nickel a bottle. (From the author's collection.)

This 1939 photo shows the old Mark Twain Memorial Bridge and Cardiff Hill. Compare this view with the one on page 10 showing this part of Hannibal and Cardiff Hill in the late 1860s. (From the author's collection.)

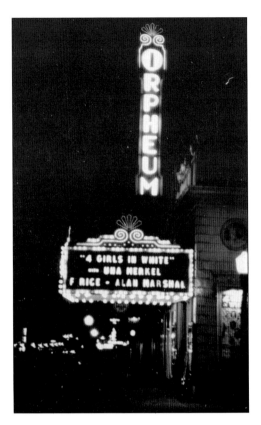

This 1939 photo shows the old Orpheum Theater at Fifth and Broadway with all of the lights brightly burning. This photo recalls the days when a Saturday night on the town was an eagerly anticipated event. (From the author's collection.)

This 1939 photo shows a view of Lovers Leap that few see anymore. At that time, a highway ran south below the Leap. This was closed in 1967 when a new Highway 79 was opened. (From the author's collection.)

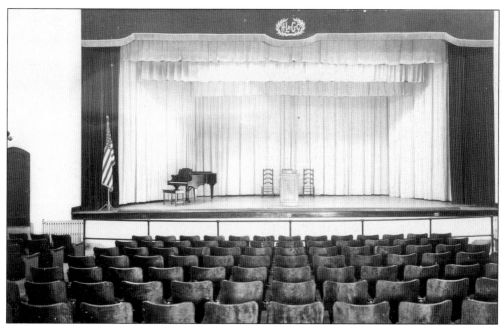

This is a photo of McKenzie Auditorium in the old Administration Building of Hannibal-LaGrange College. The "Ad Building," as it was fondly known, was built in 1929 when the college first moved to Hannibal. It was destroyed by fire, along with the gymnasium and cafeteria, in 1989. A fine new building has risen in its place. This photo dates from 1939. (From author's collection.)

This was the original library located in the administration building of Hannibal-LaGrange College as it appeared in 1939. In 1964, a new library and science building was built. (From the author's collection.)

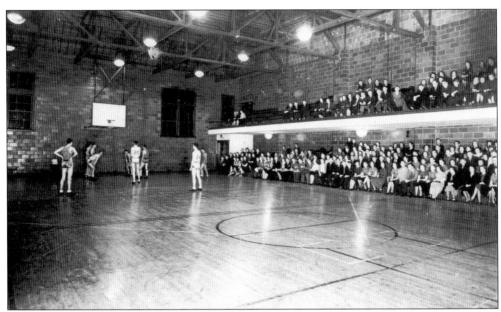

This is a basketball game in progress in the old gymnasium of Hannibal- LaGrange College. The gym was lost in the 1989 fire. This photo dates from 1939. (From the author's collection.)

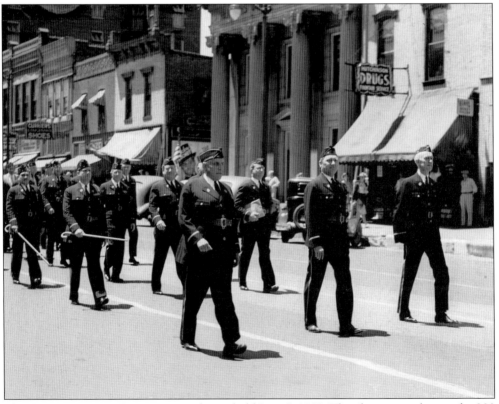

The American Legion Initiation parade was held June 3, 1939. The photo was taken in the 200 block of Broadway. (From the author's collection.)

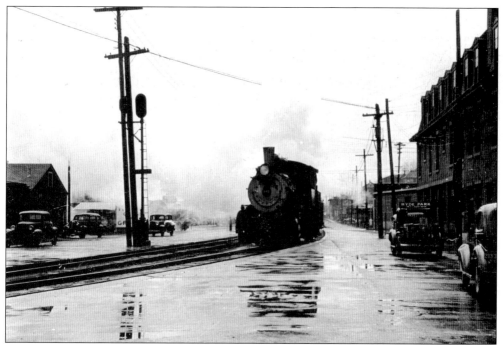

Just a dreary, rainy day in Hannibal… The photographer has captured a mood as much as a scene. This is a photo of a switching engine coming down the tracks on Collier Street. The Marion Hotel is at right. The date is 1939. (From the author's collection.)

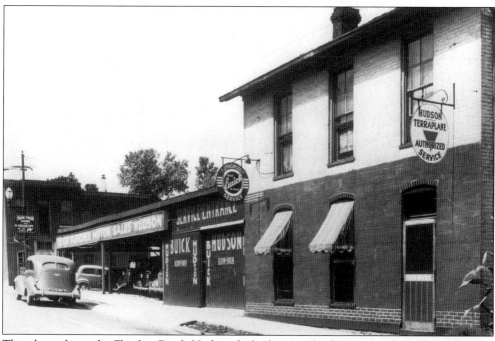

This photo shows the Fletcher Buick-Hudson dealership on Third Street in 1939. The building in the background would be razed for the Mark Twain Dinette in 1942. The lighthouse atop Cardiff Hill can just be seen above the building in background. (Courtesy of the Mark Twain Dinette.)

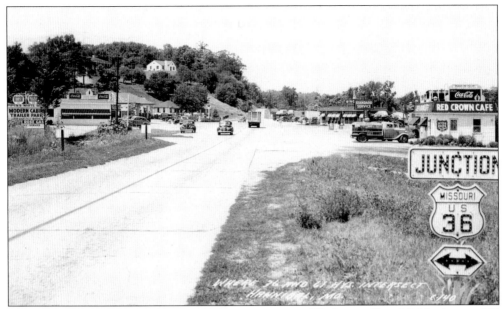

This is a view of the famous "Junction," the intersection of Highways 61 and 36 (today it is US 61 and Route MM). As the highways developed and fewer people traveled by train, Hannibal began moving out from its old boundaries. Located at this junction were the White Rose Diner at the southwest corner, Millers Cottages at the northwest corner, Renie's (later Osborne's) at the northeast corner, and Shroeder's Standard Service and Red Crown Cafe at the southeast corner. This photo dates from c. 1940. (From the author's collection.)

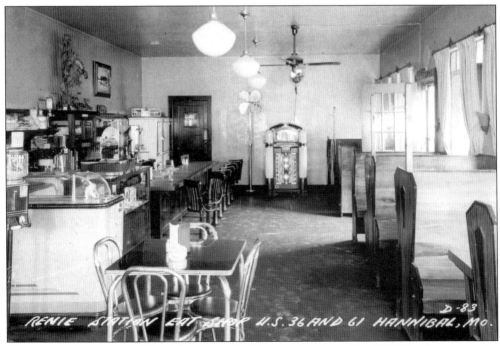

Here is an interior view of Renie's Station Eat Shop as it appeared in 1940. Renie's sat on the northeast corner of the Junction. (From the author's collection.)

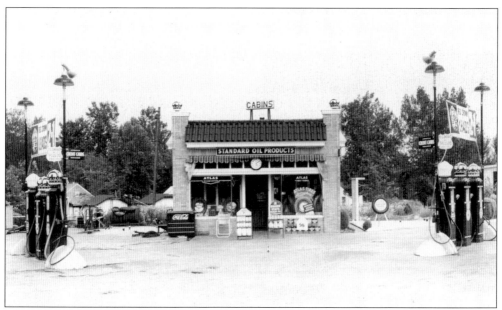

Shroeder's Standard Service was on the southeast corner of the Junction. This photo shows the station as it appeared in 1941. (From the author's collection.)

The White Rose Diner at the Junction was a favorite eating spot when this photo was taken in 1939. (From the author's collection.)

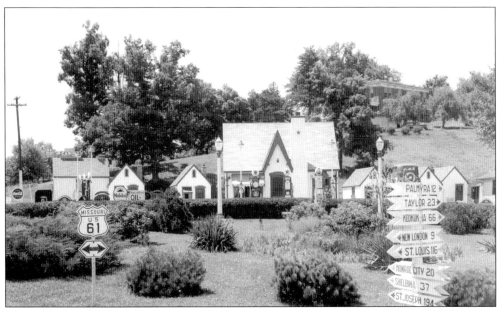

This is a view of Miller's Cottages and Texaco Service at the northeast corner of the Junction. Notice the old milepost sign. This photo dates from 1941. (From the author's collection.)

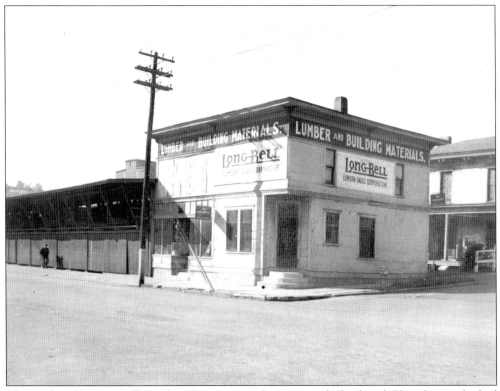

This is the old Long Bell Lumber Company at the corner of Third and Church as it looked around 1940. In 1942 Long Bell built the new store building that is today (2002) used by Jack's Harbour Marine. (Courtesy of Archie Hayden.)

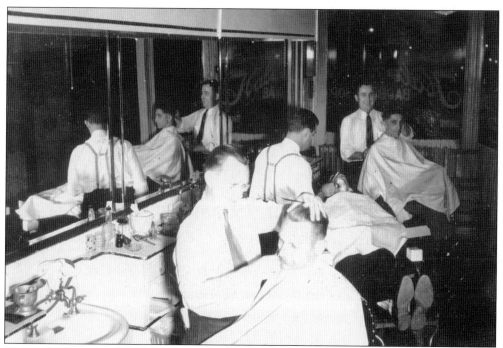

This is the interior of Hale's Barber Shop at 306 Broadway in 1939. Mark Hale is at the first chair. (From the author's collection.)

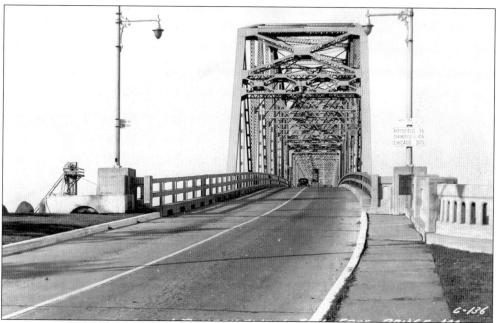

This is the Missouri approach to the old Mark Twain Memorial Bridge showing the toll booth. The bridge was a toll bridge from its opening in 1936 until 1940 when it was made a free bridge. A new span, also bearing the name "Mark Twain Bridge" was opened just upstream from the old one in September 2000. The old bridge was removed in the spring of 2001. (From the author's collection.)

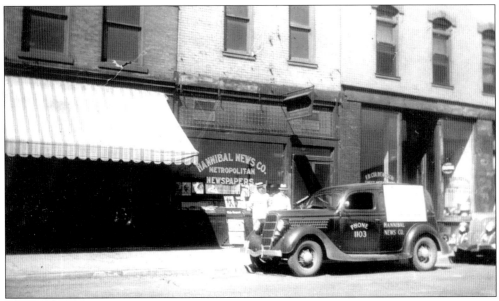

Here is the delivery truck and storefront for the Hannibal News Company from about 1940. Hannibal News was located at 222 South Main, and was owned by Frank Orth. (From the author's collection.)

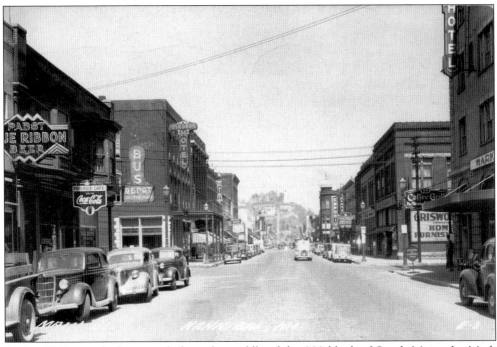

In this 1941 view looking north from the middle of the 200 block of South Main, the Mark Twain Hotel is visible at the far right. The entire east side of the 100 block south was demolished around 1991. (From the author's collection.)

This 1941 photo shows the meat department of Sonis Cash Market at 623 Broadway. Max Sonis was the owner. (From the author's collection.)

In 2002, the Mark Twain Dinette celebrated its 60th year in business. The Dinette, famous for its pork tenderloins, maid-rites, and cold root beer, began in this building at Third and Hill in 1942. (Courtesy of the Mark Twain Dinette.)

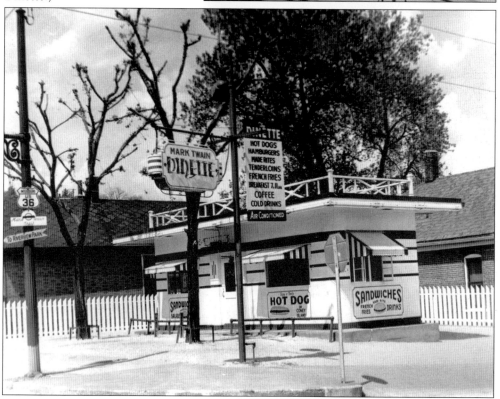

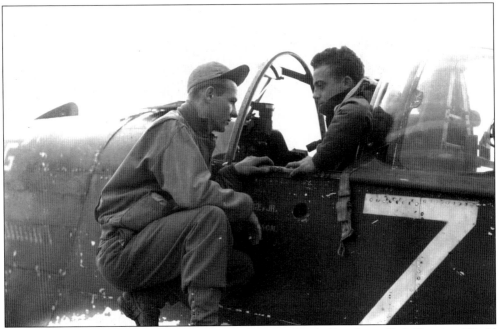

Hannibal has given of its sons and daughters whenever Uncle Sam has called. Here is a World War II photo of Hannibal native T/Sgt. Vernon G. Person, on the wing of a P-51 Mustang after completing a recon mission somewhere in France in 1944. (From the author's collection.)

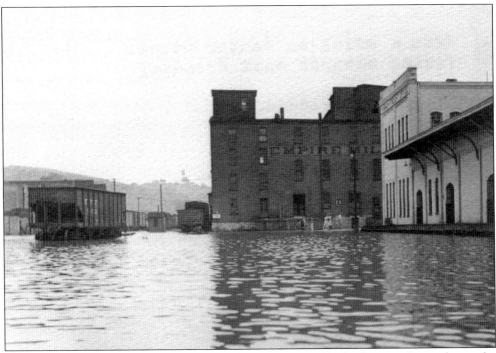

This photo looks south towards East Broadway from the 100 block of Center Street during the flood of 1944. Visible are the old Wabash Freight House at right (demolished in 1962), and the Empire Mills (demolished around 1965). (Courtesy of Archie Hayden.)

Four

JUST YESTERDAY

1946–PRESENT

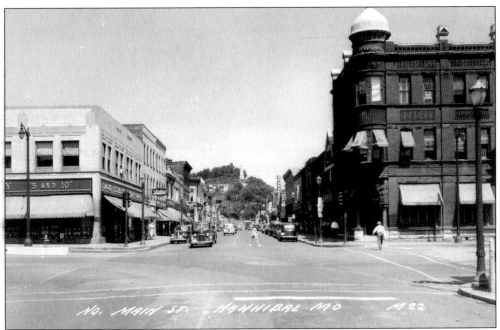

This photo looks north on Main Street from the Broadway and Main intersection in 1947. The old facade and turret of Hannibal National Bank are visible at right. The bank was completely refaced with a modern exterior in 1953, the same exterior seen today. (From the author's collection.)

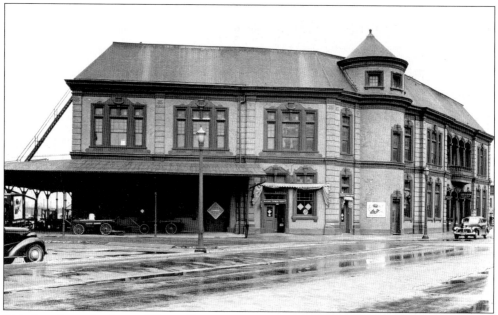

This shot shows the front of Union Depot as it appeared in its later years. The tall clock tower, which could be seen from most parts of town, was removed around 1930, as were the third floor dormer windows. Even with much of the ornate trim removed, the old Depot was still a beautiful building. (Courtesy of Archie Hayden.)

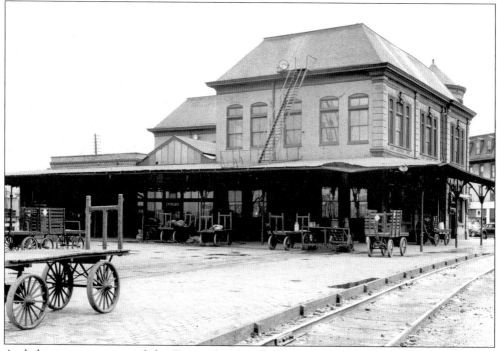

And this is a rear view of the Depot showing the passenger entrance, ticket window, and baggage wagons. This photo was taken around 1951. Marion Hotel is visible in the distance. (Courtesy of Archie Hayden.)

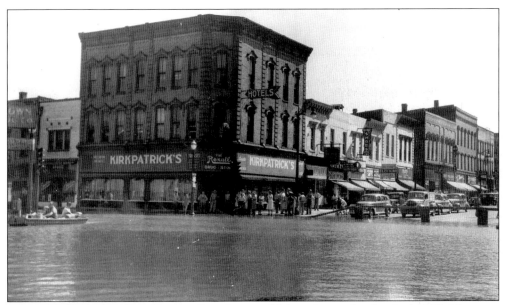

Here is Kirkpatrick's Drug Store at Broadway and Main during the flood of 1947. The river flood stage reached 24.1 feet that year, the highest level recorded to that date. During the great flood of 1993, the river reached 31.3 feet for an all-time record, but the heart of the downtown was protected by a new levee that had just been completed. (From the author's collection.)

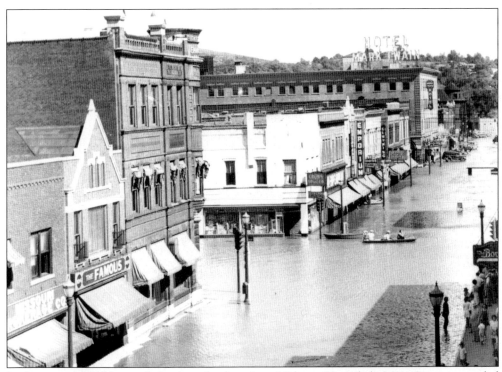

Looking more like Venice, Italy, than the American Midwest, Hannibal's Main Street is traveled by boaters rather than cars during the flood of 1947. This view looks south on Main Street. The Broadway and Main Street intersection is in the foreground. (From the author's collection.)

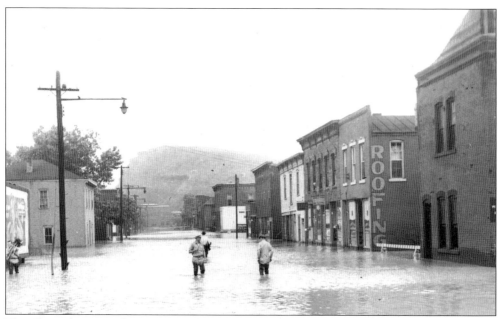

This photo shows South Main Street looking south towards Lovers Leap during the 1947 flood. At right is the old St. Louis and Hannibal Depot. The Burlington Shops are barely visible at the end of Main Street below Lovers Leap. (From the author's collection.)

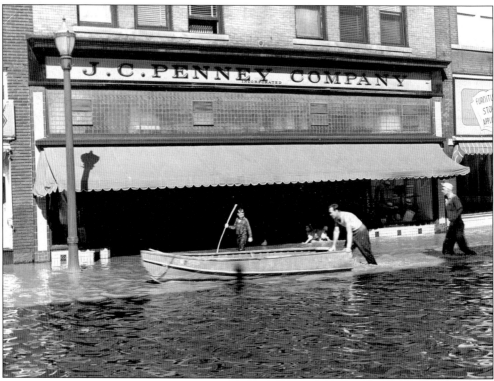

Here is a photo of boaters on South Main Street in front of the J.C. Penny Store during the flood of 1947. (From the author's collection.)

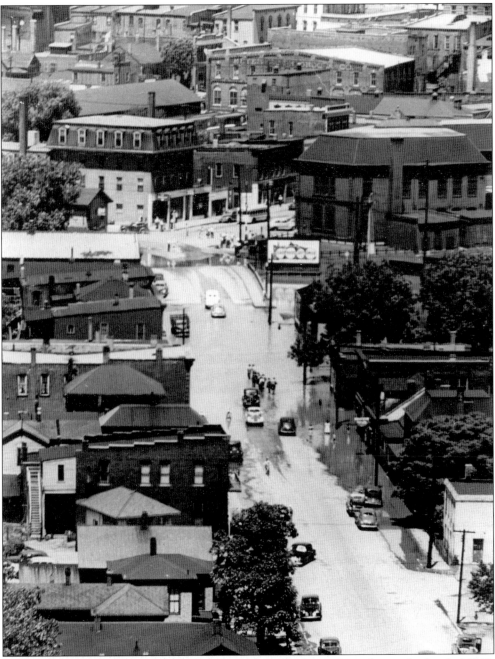

This is a telescopic view of South Main Street taken from Lovers Leap during the flood of 1947. South Hannibal was a very busy area, a stark contrast to the barren sea of empty lots one sees today. (Courtesy of Archie Hayden.)

Floods weren't Hannibal's only peril. Here is a view of the aftermath of a bad tornado that struck Hannibal on December 12, 1949. This view looks south on Third Street from the Mark Twain Bridge Approach. The roof has collapsed on the old Box Factory building (at time of photo it housed Cookie's Tire shop), and several houses have been damaged or destroyed. The old Box Factory is presently (2002) the site of the Clemens Hotel. (Courtesy of Mark Twain Dinette.)

Bowman's Cafe and Sinclair Station (later Osborne's) was at the northeast corner of the Junction in 1946 when this photo was taken. Today (2002) Cassano's Pizza sits at this location. (From the author's collection.)

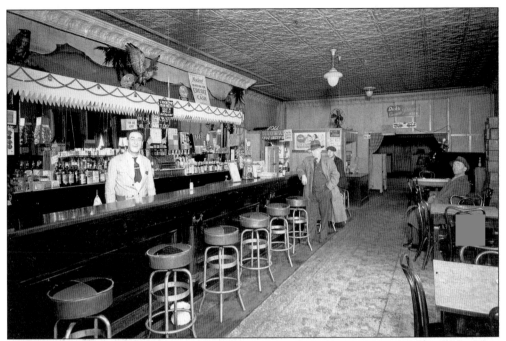

Hoag's Tavern was well-known for its good food. It was located at 203 North Main. This photo dates from about 1950. (Courtesy of Archie Hayden.)

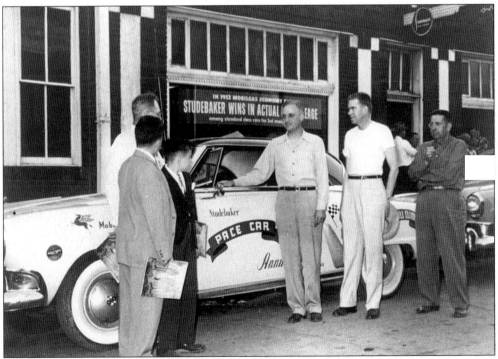

The 1952 Studebaker Pace Car that had been used in the Mobilgas Economy Run for that year came to Hannibal and was on display at the King and Sons Buick Studebaker dealership. King and Sons was located at 105–17 South Fourth Street. (From the author's collection.)

This is the waiting room of the old Union Depot prior to its demolition in 1953. Over nearly 70 years, thousands of people came in and out of Hannibal via this depot. Truly the old depot served Hannibal well. (Courtesy of Archie Hayden.)

This was the second floor mezzanine area of the old depot. Now boarded up, at one time it looked down into the main entry area. Notice how supports have been added to stabilize the second floor. A hotel was located on the third floor at one time; it was long gone by the time this photo was taken. (Courtesy of Archie Hayden.)

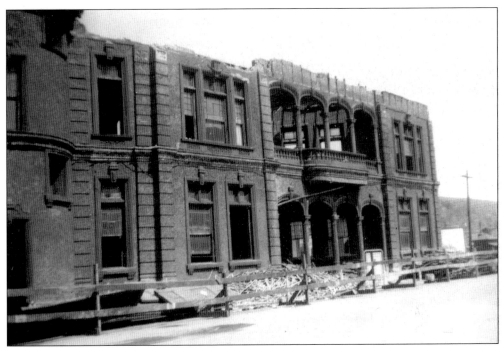

In this photo, demolition work is in progress at the old Union Depot in 1953. Declining passenger rail use and an aging building brought to a close a very colorful chapter in Hannibal's history. A newer depot was built by the Burlington on the site of the old one, but by 1967, passenger rail service had ended in Hannibal. (Courtesy of Archie Hayden.)

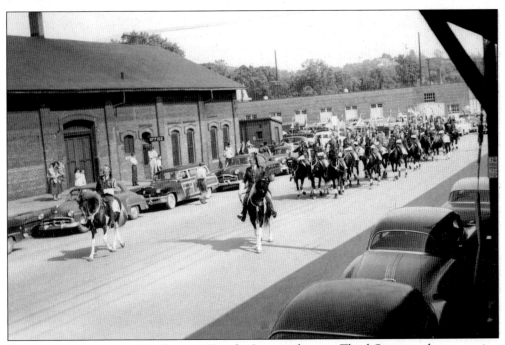

This is a photo of the 1955 Shriners' Parade. It was taken on Third Street as the procession headed towards Broadway. (Courtesy of Archie Hayden.)

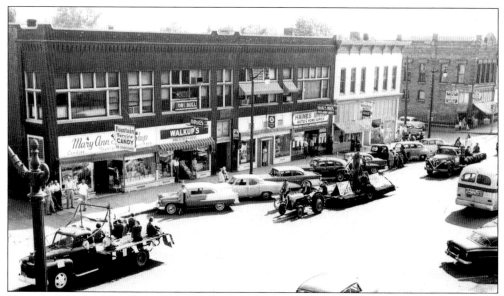

Hannibal's Federal Building provided the excellent vantage point for this photograph of the 1955 Hannibal High School homecoming parade. Visible in background are the Mary Ann Sweet Shop, Walkup's Pharmacy, Haines Auto Supply, and Broadway Market. (Photo courtesy of Kathy Threlkeld.)

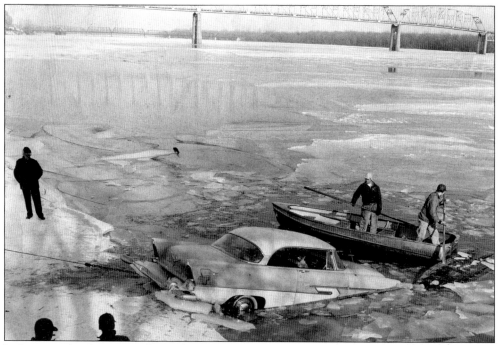

In January of 1956, six travelers from Ohio got lost while trying to cross the Mark Twain Bridge and accidentally drove out onto the frozen surface of the river at Broadway. The car slid 50 feet onto the ice before breaking through. All six passengers, including an eight-month-old infant, were rescued and taken to Levering Hospital where they recovered. The next day, their brand new 1956 Plymouth was pulled out of the river. (From the author's collection.)

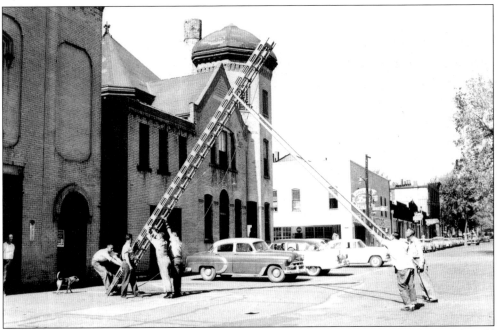

The Hannibal Fire Department was conducting a ladder drill in this 1956 photo. The old Fourth Street Fire Station, built in 1871, was replaced with the current one in 1966. The Hannibal Police Station next door was vacated in 1976 when the new station opened, and that building survives today (2002) as a museum. All but forgotten today, the old dome atop the police station was still in place at the time of this photo. (Courtesy of Kathy Threlkeld.)

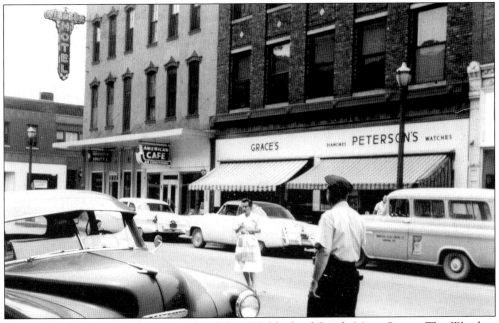

This 1956 photo shows the west side of the 100 block of South Main Street. The Windsor Hotel, Graces', and Petersons' Jewelry were all destroyed by fire in 1962. During his last visit to Hannibal in 1902, Mark Twain stayed at the Windsor Hotel. (Courtesy of Kathy Threlkeld.)

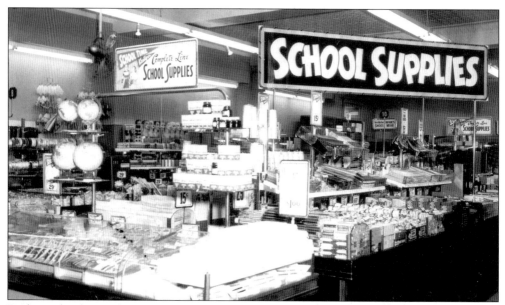

Back to school time always prompted sales at all of the stores. Pencils, notebooks, crayons, and many other items were sold. This is a photo of the "Back to School" sale at Kresge's in August of 1956. (Courtesy of Kathy Threlkeld.)

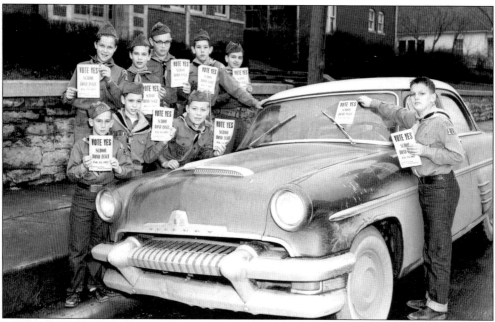

In February of 1957, Hannibal voted on a bond issue to build a new Junior High School. In this photo, Boy Scout troop #112 helped campaign for this bond issue by passing out flyers. Here they place a flyer on the windshield of a dusty Mercury in front of Stowell School. The bond issue passed and the Junior High (now Hannibal Middle School) was built. Pictured here, from left to right, are the following: (front row) Eddie Beaston, Charles Smith, and Bill Houser; (back row) Joe Pridgeon, Ronnie Jackson, Bill Holliday, Jim Runyon, and Gary Hendren. Jim Evans is placing the flyer. (Courtesy of Kathy Threlkeld.)

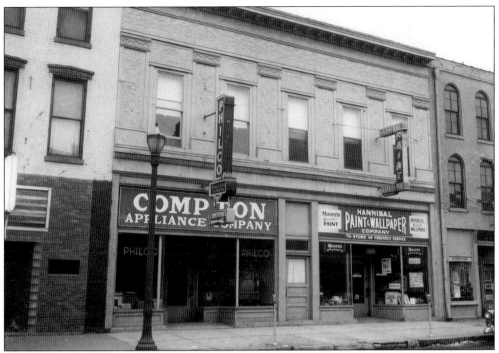

This 1957 photo shows Compton Appliance and Hannibal Paint and Wallpaper, which were located on the 200 block of North Main Street at that time. Mississippi Dry Goods currently (2002) occupies the building. (Courtesy of Kathy Threlkeld.)

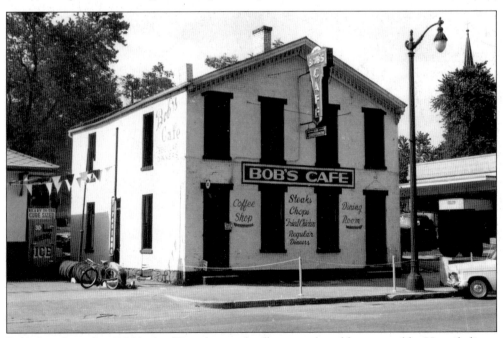

Bob's Lunch in the 600 block of Broadway is fondly remembered by many older Hannibalians. This June 1958 photo shows the restaurant before its removal for the new Clayton Savings and Loan building. (Courtesy of Kathy Threlkeld.)

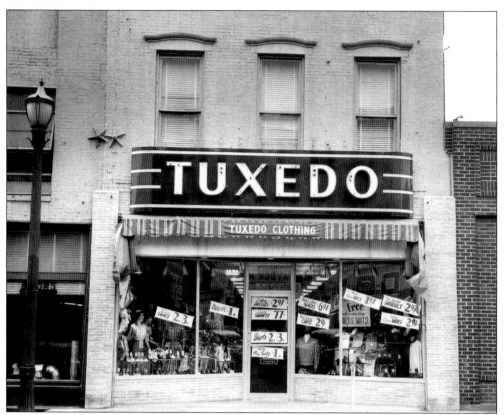

This is a photo of the Tuxedo Clothing Store at 206 North Main in 1958. Sam Resnick was the manager. The building was destroyed by fire in the 1960s and is now a vacant lot. (Courtesy of Kathy Threlkeld.)

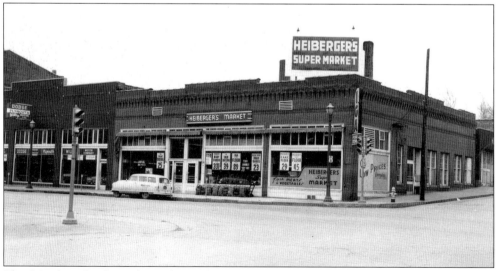

This March 1958 photo shows the Heiberger's Supermarket at Third and Center. Heiberger's was the IGA market. Today (2002) KHMO Radio occupies this building. (Courtesy of Kathy Threlkeld.)

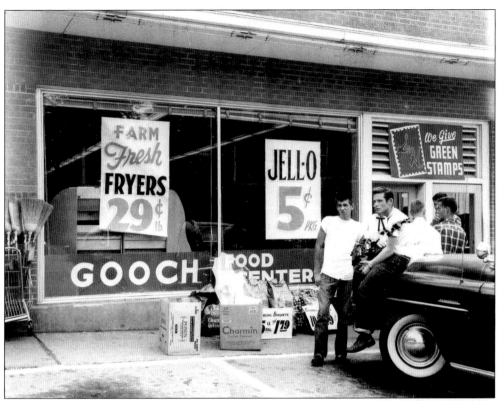

This is a photo of Gooch's Food Center on Grand Avenue in June 1958. It looks as if some of the locals are ready to go cruisin'. (Courtesy of Kathy Threlkeld.)

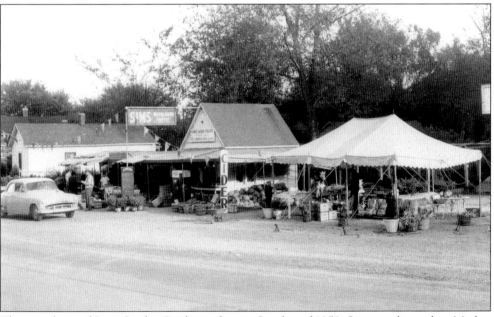

This is a photo of Sims Garden Produce taken in October of 1958. Sims was located on Market Street in Oakwood near Tilden School. (Courtesy of Kathy Threlkeld.)

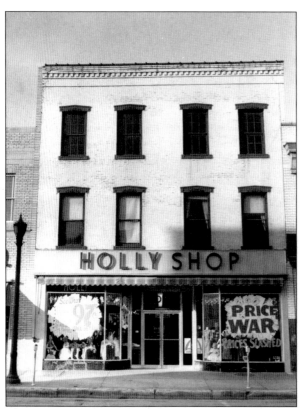

The Holly Shop at 111 North Main was having a 97¢ sale in October 1958 when this photo was taken. (Courtesy Kathy Threlkeld.)

This 1958 view of the heart of the Mark Twain Historic District shows the east side of the 300 block of North Main before it was developed as a tourist area. The first three buildings to the right, all dating back to the city's early days, were razed in 1968 for a parking lot. In this photo, city workers are putting up street decorations for Christmas. (Courtesy of Kathy Threlkeld.)

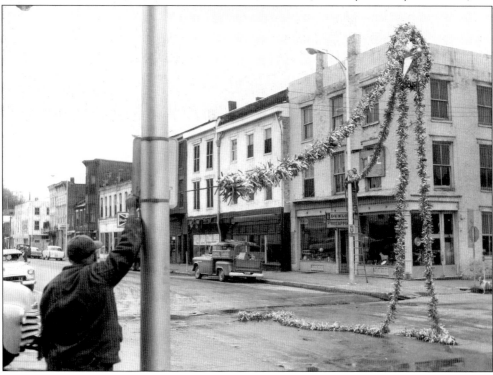

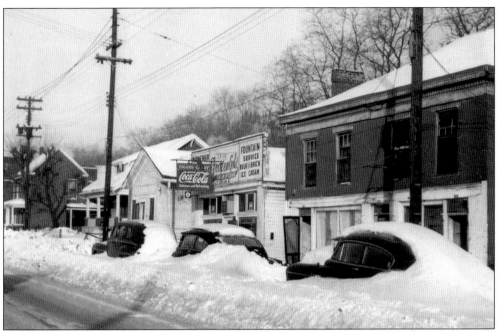

Brother, have you got a snow shovel? This photo shows a pretty decent covering of the chilly white stuff in the 400 block of Mark Twain Avenue. This photo was taken in January 1959. (Courtesy of Kathy Threlkeld.)

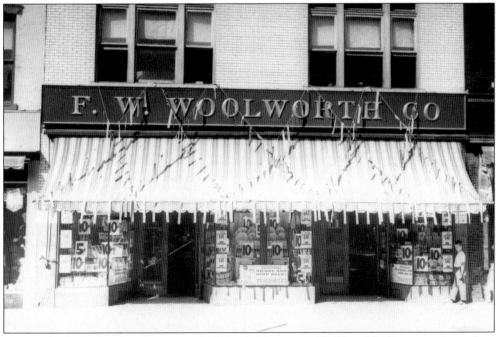

Here is the F.W. Woolworth store at 115 North Main in 1959. The old "dime stores" got their name from the fact that they sold nothing for more than 10¢. Although by 1959, the true dime store was already a thing of the past, this 5¢ and 10¢ sale advertised here showed there were still many things that could be bought for a dime. (Courtesy of Kathy Threlkeld.)

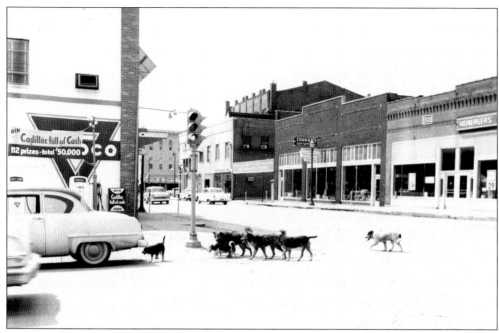

This is a view looking from Center to Broadway along Third Street. Some sort of canine game of "follow the leader" seems to be going on in the foreground. This photo dates from 1959. (Courtesy of Kathy Threlkeld.)

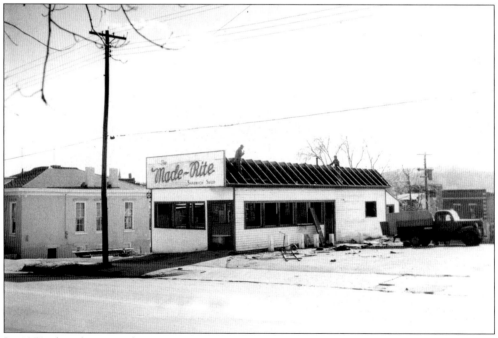

In 1959, demolition work was in progress on the Made-Rite Sandwich Shop on Broadway to make way for the new Kroger store parking lot. If you look carefully, you may note an old bathtub inside the building. A rather curious fixture for a sandwich shop! (Courtesy of Kathy Threlkeld.)

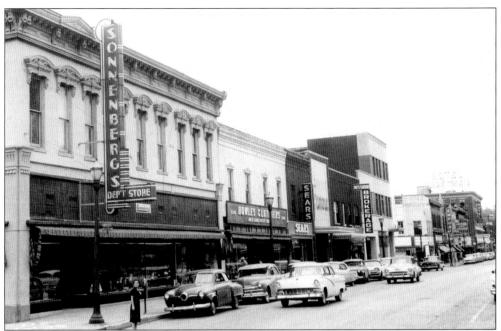

This photo shows the east side of the 100 block of North Main in 1959. At left is the old Sonnenberg's Department Store. Sonnenberg's began business before 1900 as Sonnenberg & Meyer, later became Sonnenberg & Son, and finally, Sonnenberg's Department Store. They closed in 1959. (Courtesy of Kathy Threlkeld.)

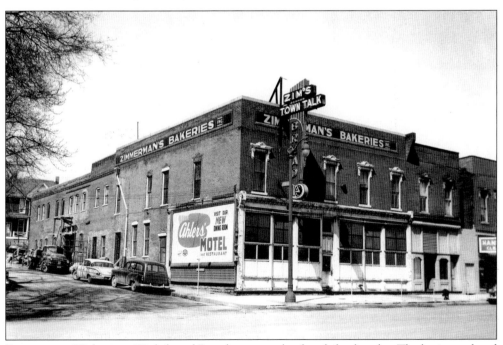

Zimmermans' Bakeries at Eighth and Broadway was a landmark for decades. The business closed in 1959 and the following year, the Pastry Box opened in the same location. This photo shows the bakery as it appeared in the late 1950s. (Courtesy of Kathy Threlkeld.)

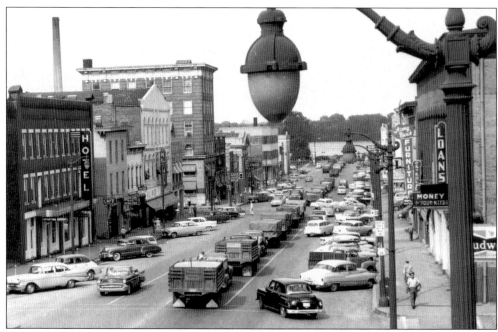

One of Hannibal's old "hanging egg" streetlights on Broadway frames a view of grain trucks waiting to unload at Empire Mills on East Broadway. Photo dates from the late 1950s. These streetlights, installed in the 1930s, were replaced by modern mercury vapor types in 1963. The old posts they were mounted on were retained, and forty years later, some are still in use. (Courtesy Kathy Threlkeld.)

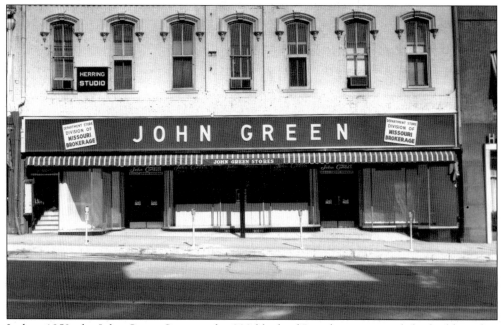

In late 1959, the John Green Store in the 300 block of Broadway occupied the building that the Golden Ruler now occupies. Kline's had previously used the space, but relocated to 118 North Main after Sonnenberg's Department Store closed. (Courtesy of Kathy Threlkeld.)

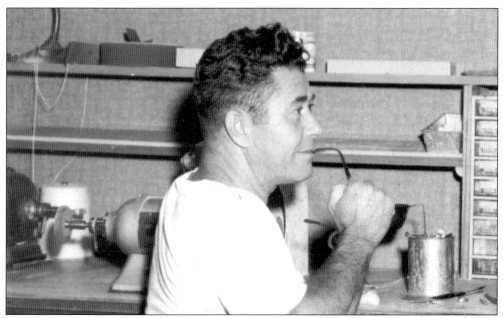

This 1960 photo shows the Hannibal Dental Lab, operated by Allen Milner in the Fidelity Building at 617A Broadway from 1957 to 1971. Milner made and repaired dentures for many Hannibal residents during that time. (From the author's collection.)

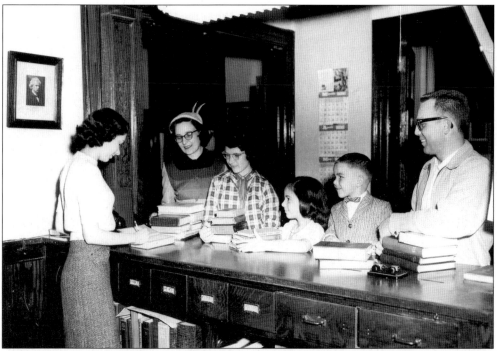

This March 1958 photo shows the old circulation desk at the Hannibal Public Library. The gentleman at the far right is Elmer Myers, a math teacher at Hannibal High School. He later became principal there. This desk was removed during the library remodeling/expansion of 1986. (Courtesy of Kathy Threlkeld.)

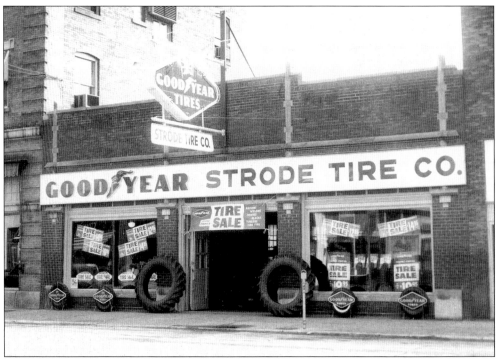

Strode's Tire Service sat on the south end of the Mark Twain Hotel, at 212 South Main. The building was removed for construction of the flood wall in the early 1990s. This photo dates from 1960. (Courtesy of Kathy Threlkeld.)

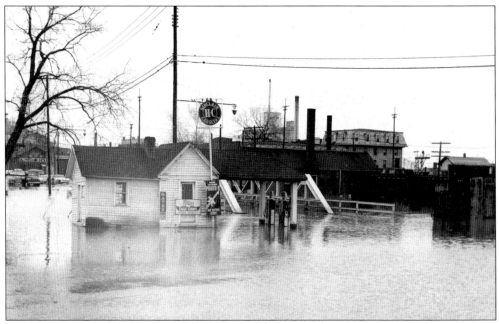

This photo taken during the flood of 1960 shows Lowe Sinclair filling station at 500 South Third and the Third Street Bridge in background. Farther beyond the top of the Marion Hotel is visible. (Courtesy of Kathy Threlkeld.)

Picadilly Package Liquors occupied this building at the junction of Mark Twain Avenue, Third Street, and the Mark Twain Bridge Approach when this photo was taken in 1960. The building was torn down in the early 1980s. (Courtesy of Kathy Threlkeld.)

This photo (c. 1960) shows a view looking up Broadway as seen from one of the windows of the Hannibal Trust Building. Visible at far left is part of the old Brittingham Hall building (razed in 1964). In the photo is a marching band from one of Hannibal's many parades. (Courtesy of Kathy Threlkeld.)

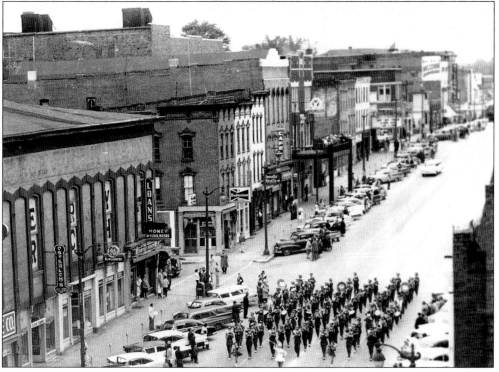

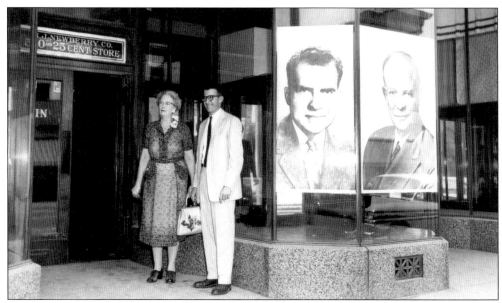

This photo was taken during the 1960 Presidential Election. Posted prominently is the picture of President Eisenhower, along with the Republican candidate, Richard Nixon. Nixon, of course, lost the election that year to John F. Kennedy. At left is Mrs. William Blackshaw, secretary of the Marion County Republican Committee, and Albert Rendlen, Chairman. The photo was taken at J.J. Newberry in the 200 block of Broadway. (Courtesy of Kathy Threlkeld.)

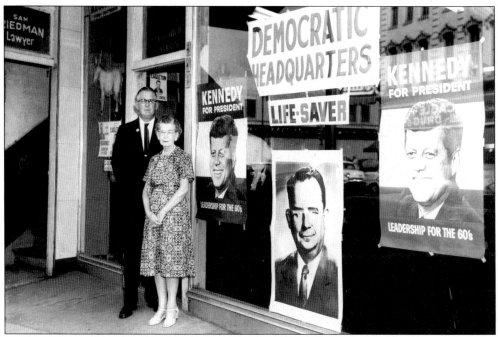

Here is the Democratic Campaign Headquarters in the 100 block of South Main during the 1960 election. The gentleman on the left is J. Marvin Bounds, Chairman of the Marion County Democratic Central Committee, and at right is Mrs. Ina Sheu, committee Vice Chairman. (Courtesy of Kathy Threlkeld.)

Here is the Parkview Cafe and PD Package Liquor in the 400 block of Broadway as they appeared in November of 1961. Brashears TV and Radio Repair is barely visible at far left. (Courtesy Kathy Threlkeld.)

This is a 1961 photo of the Hannibal Police Department in front of the old Police Station at Fourth and Church. The officers pictured here, from left to right, are as follows: (front row) Arlo Baldwin, Franklin Neff, Charles Webster, John Foley, Chief Carl Brink, Sam Dindia, Milford Trail, and Mignonne Kilian; (second row) Levi Whitlock, Floyd Capp, Harold Tourney, Raymond Marshall, Don Salter, and Ken Hendrix; (third row) Jim Smith, Lloyd Kayler, Jim Wisner, Ken Grace, Vernon Couch, and William Nulton; (fourth row) William Bone, Don DeLaPorte, and Don Radford. (Courtesy of Kathy Threlkeld.)

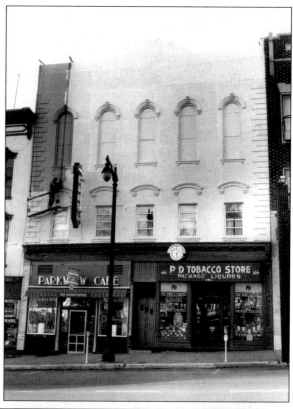

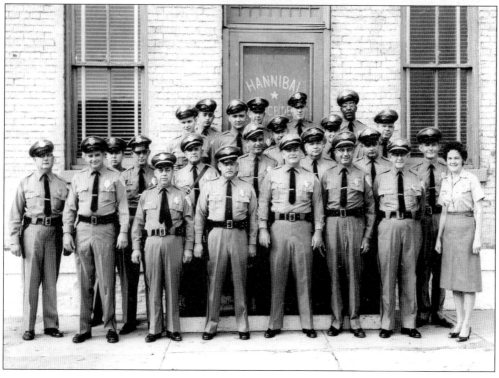

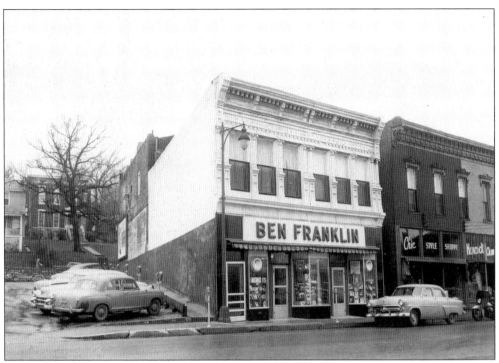

The Ben Franklin sat at 1300 Market Street near the Wedge intersection of Broadway and Market when this photo was taken in November of 1961. (Courtesy of Kathy Threlkeld.)

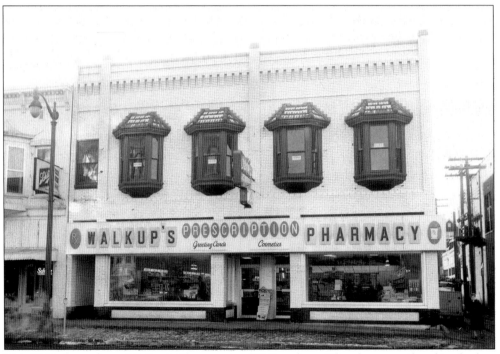

This 1961 photo shows Walkup's Pharmacy at 615 Broadway. The pharmacy closed in the late 1970s. (Courtesy of Kathy Threlkeld.)

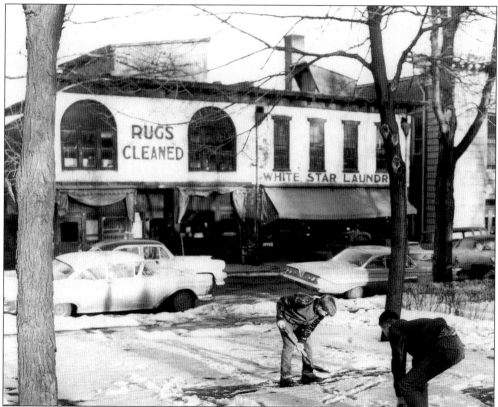

These two buildings on Fourth Street housed the White Star Laundry. The building on the right with the arched windows was torn down in 1962 and replaced by a newer structure. A worker was killed while taking down the old building. The structure on the right hand side partially collapsed in 1986, and it was removed and also replaced with a newer one. At far right, part of city hall can be seen. This photo dates from 1961. (Courtesy of Kathy Threlkeld.)

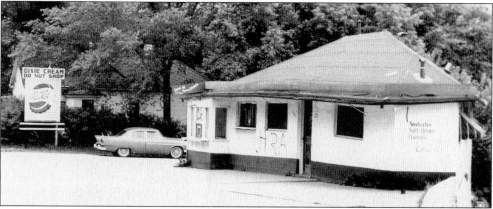

The Dixie Cream Donut Shop was located in this building at 2629 St. Marys in May of 1962. This building is better remembered as the Goody-Goody Sandwich Shop, which was operated here many years. This building would be removed in 1963 for the new Smith's Funeral Home. The "HRA" graffiti on the side was spray painted by some local high school boys; it stood for "Hell Raisers Association." (Courtesy of Kathy Threlkeld.)

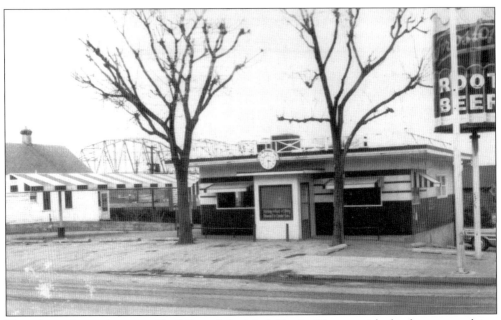

This photo shows the second building of the Mark Twain Dinette with the famous revolving root beer mug sign as it appeared in 1962. This building was replaced by the present building in 1965. (Courtesy of the Mark Twain Dinette.)

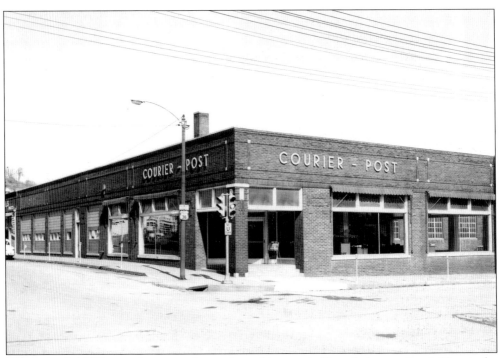

When the Cold War was big news, this is where the news in Hannibal was printed. Here is the *Hannibal Courier-Post* building as it appeared in October 1962. This building at Third and Center was originally a Ford automobile dealership before it was purchased by the newspaper. (Courtesy of Kathy Threlkeld.)

This is F & M Bank at their 212 Broadway location in September 1962. This is the second home for the bank, which was founded in 1870. This beautiful structure, built in 1911, was used by the bank until they relocated to Fifth and Broadway in 1970. The building today (2002) is the home of Big River Discount Books. (Courtesy of Kathy Threlkeld.)

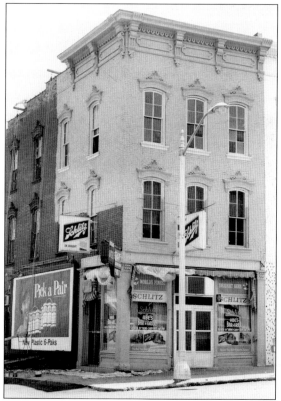

When this picture was taken in 1963, this building at Broadway and Fourth was the location of Abe's Bar and Grill. It was owned by Mrs. Nellie Toalson. (Courtesy of Kathy Threlkeld.)

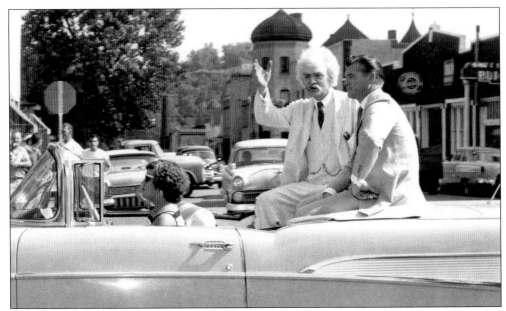

Could that be Mark Twain riding in a '57 Chevy? Actually, it is Hal Holbrook portraying the famed humorist, and this photo was taken during the Tom Sawyer Days Parade in 1957. Every year, Hannibal's National Tom Sawyer Days draws thousands of people from all over the country to see the Fence Painting Contest, fireworks display, and other activities. The event began in 1956. (Courtesy of Kathy Threlkeld.)

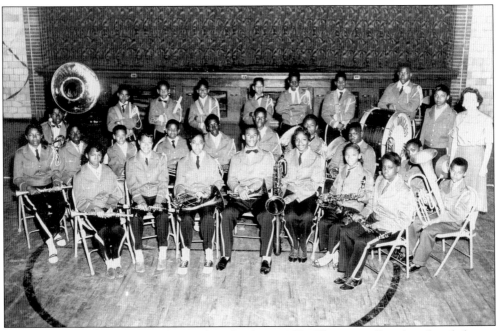

This is the last band of Douglas High School in 1959. That year, Douglas closed due to desegregation, and its students were incorporated into the other schools of the Hannibal Public School system. The last remaining portion of the old school building, which stood on Willow Street near Market, was demolished in 2000. (Courtesy of Kathy Threlkeld.)

INDEX